100枚
レターブック
100 Papers
和もよう
with Japanese Patterns

Designed
by
12 Japanese
Artists

MW00635782

はじめに
Foreword

『100枚レターブック』は、クリエイターオリジナルの
「かわいい紙」を集めた本です。
真っ白なつるつるの紙・クリーム色のざらざらの紙・
わら半紙のような古紙・茶色いクラフト紙など、
色や質感の違う4種類の紙で、
50柄×2枚＝100枚の便箋を収録しています。

本書のテーマは、「和もよう」。
イラストレーター・グラフィックデザイナー・
老舗和紙店・てぬぐい専門店など、
12名の作家によるデザインです。
伝統的な柄からモダンなパターンまで、
バラエティ豊かな和柄の紙を1冊にまとめました。

1枚1枚をきれいに切り離せるので、
便箋として使うのはもちろん、
封筒、ぽち袋などの紙もの作りにも使えます。
四つ折り・六つ折りにした紙がぴったり入る封筒
（P7-大・P9-大）など、型紙も多数掲載しました。

手紙を書いたり、紙ものを作ったり、
使い方はアイデア次第。
その日の気分や送る相手に合わせて、
さまざまに楽しめる1冊です。

PIE BOOKS 編集部

100 Writing and Crafting Papers is a collection of original,
kawaii, patterned papers conceived by illustrators, designers
and other creatives.
Contained within are one hundred sheets, two each of fifty
different patterns printed on one of four different colored/
textured paper stocks: smooth white, toothy cream-colored,
warabanshi-like grayish recycled, and brown kraft.

The theme of this collection is "Japanese patterns." The
designs come courtesy of 12 artists active as illustrators,
graphic designers, longstanding purveyors of washi, makers
of tenugui cloths, and more.
Their patterns ranging from traditional to modern come
together to form a book of Japanese patterns rich in variety.

Bound so that they tear out easily, sheet by sheet, the papers
can be used for letter-writing, or to make envelopes, standard
and mini.
Included are a number of templates, such as for envelopes
just the right sizes for a sheet of letter paper folded in four (p.
7, large) or folded in six (p. 9, large).

A book guaranteed to make writing notes and papercraft
more fun. Select a paper to match your mood or recipient –
the uses are yours to imagine!

The editors PIE BOOKS

<使用上の注意>
・ページをしっかり開き、ゆっくり引っ張るとよりきれいにはがれます。
・本書掲載の型紙で作成した封筒は、郵送用には使用できません。

<Notes>
· In removing pages, open the page fully and pull slowly to ensure
a clean tear.
· Envelopes made with the templates provided in this book
cannot be sent by post.

封筒・ぽち袋の作り方

本書に収録した紙を使って、封筒やぽち袋を作ることができます。
繰り返し使えるよう、型紙をコピーし、厚紙で作るのがおすすめです。

 型紙を実線で切り取る。
使いたい紙の表面に型紙をの
せ、えんぴつなどで型を取り、
カッターで切り取る。

 封筒：①〜④の順に山折りし、
のりしろ○の裏面をのり
づけする。

 ぽち袋：A〜Dの順に山折り
し、のりしろ▲、のり
しろ■の順に裏面を
のりづけする。

Making envelopes

Use the papers provided in this book to make
envelopes large, small and mini. In order to able to
use the templates over and over again, we recommend
copying them onto sheets of heavy paper.

Directions

1. Cut out the template along the solid lines.
2. Lay the template on the outside of the paper of
your choice. Trace the outline of the template in
pencil or pen onto the paper. Cut along the lines
with a cutting knife and remove the envelope to be.
3. For stationery envelopes: Fold tabs 1–4 (in that
order) back in "mountain folds" and apply glue to
the back side of the glue tabs marked○. For mini
money envelopes: Fold tabs A–D (in that order)
back in "mountain folds" and apply glue to the glue
tabs marked ▲ and ■ (in that order).

封筒 Envelope

表　　　裏

ぽち袋

MIni envelope

表

裏

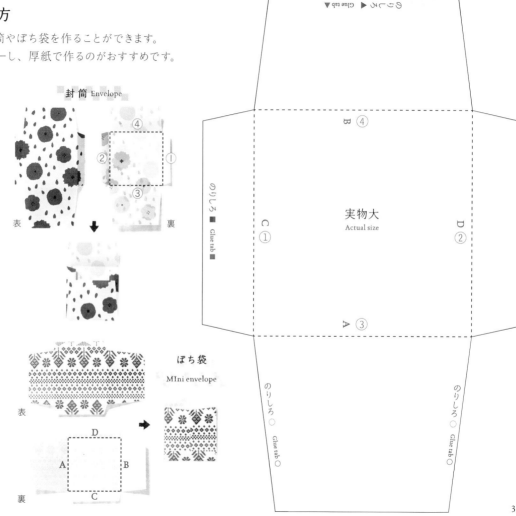

実物大
Actual size

② D

正方形（大）Square envelope (large)

Glue tab ○

② D

Glue tab ○

④
B

のりしろ ▲ Glue tab ▲

④
B

③
A

正方形（小）

Square envelope (small)

① C

Glue tab ○

のりしろ ▲ Glue tab ▲

のりしろ ■ Glue tab ■

のりしろ ■ Glue tab ■

5

② D

のりしろ ○ Glue tab ○

長方形(大) Rectangular envelope (large)

② D

のりしろ ○ Glue tab ○

のりしろ ▲ Glue tab ▲

のりしろ ▲ Glue tab ▲

④ B

④ B

③ A

長方形(小)

Rectangular envelope (small)

のりしろ ○ Glue tab ○

① C

のりしろ ■ Glue tab ■

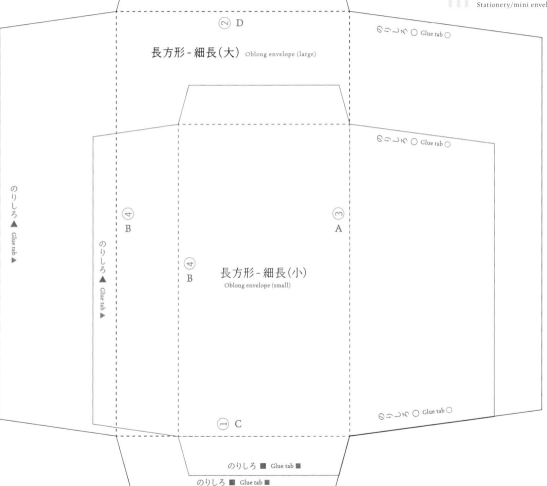

②　D

長方形 - 細長（大）　Oblong envelope (large)

のりしろ ◯ Glue tab ◯

のりしろ ◯ Glue tab ◯

のりしろ ▲ Glue tab ▲

のりしろ ▲ Glue tab ▲

④
B

③
A

④
B

長方形 - 細長（小）
Oblong envelope (small)

のりしろ ◯ Glue tab ◯

①　C

のりしろ ■ Glue tab ■

のりしろ ■ Glue tab ■

収録クリエイター
プロフィール

The artists

かまわぬ

1987年創業。東京代官山に本店を構え、昔ながらの「注染」の技法にこだわった本染めてぬぐいの専門店。店名には「特別にお構いも出来ませんがお気軽にお立ち寄りください」という意味を込めている。てぬぐいは江戸小紋柄・季節柄・動物柄など古典から現代柄まで常時250種類以上を取りそろえ、古き良きものを現代の感覚で伝えながら、暮らしへの取り入れ方を提案している。
kamawanu.co.jp

Kamawanu
Established in 1987. With their flagship store in Tokyo's Daikanyama district, Kamawanu specializes in tenugui dyed cotton cloths made using age-old chusen dying techniques. The store name contains the idea that "while we won't be offering anything lavish, we hope you'll feel free to stop by." With more than 250 varieties of tenugui ranging from traditional Edo-komon, seasonal and animal patterns to contemporary designs, Kamawanu proposes ways to incorporate this good old item into today's lifestyle with modern flair.
kamawanu.co.jp

goodman inc.
大野好之 グッドマン インク
おおのよしゆき

グラフィックデザイナー・アートディレクター。goodman inc.代表。広告、編集などを中心にブランドの立ち上げや商品開発などを展開。京都宮川町に、手紙まわりのオリジナル文具を扱うお店「裏具」を2006年にオープン。制作から販売まで京都を中心に展開している。
www.uragu.com

goodman inc. / Yoshiyuki Ono
Graphic designer, art director. President of goodman, inc. Centered on advertising and editorial, their work extends to branding and product development. Specializing in original letter-related stationery, their retail store Uragu was opened in 2006 in Miyagawacho, Kyoto. Operations ranging from production to retailing are centered in Kyoto.
www.uragu.com

桂樹舎

けいじゅしゃ

昭和35年創業。八尾和紙の伝統を受け継ぎながら新しい和紙の道を切り拓いてきた、和紙業界においても特異な存在の和紙メーカー。豊富なカラーバリエーションの手すき染紙や、型染め技法による色鮮やかでありながらあたたかみのある加工品の製造を得意とする。重要無形文化財の芹沢銈介の和紙型染カレンダーの製作販売もしている。
www.keijusha.com

Keijusha
Established in 1960. Keijusha maintains a unique presence in the washi papermaking industry for carrying on the traditions of, while carving out a new path for, Yatsuo washi. Specializes in handmade Japanese paper dyed in a rich variety of colors and warm yet colorful stencil-dyed paper products. Produces and sells calendars featuring the stencil-dyed washi of Keisuke Serizawa, designated a Living National Treasure for his stencil-dyeing techniques.
www.keijusha.com

coton design

酒井博子

コトンデザイン さかいひろこ

1981年兵庫県生まれ。広告制作会社、room-composite を経て2011年独立。ひとのこころをコトンと動かすようなデザインをテーマに、ロゴ・エディトリアル・CDジャケット・Web などさまざまな分野で活動中。香港国際ポスタートリエンナーレ Certificate of Honour、Graphis Poster Annual 2016 Silver 受賞。審査員賞、ラハティ国際ポスタービエンナーレ
coton-design.com

coton design / Hiroko Sakai
Born 1981 in Hyogo Prefecture. After working with the advertising production company room-composite, she launched her own practice in 2011. Works in various disciplines including logo, editorial, CD jacket and web design, making it her aim to create work that moves people's hearts. Awarded the Bronze / Judges Choice at the 2010 Hong Kong International Poster Triennial, Certificate of Honour at the 2011 Lahti Poster Biennial, and Silver at the 2016 Graphis Poster Annual.
coton-design.com

小関祥子

こせきしょうこ

切り絵やコラージュの技法で作品を制作するイラストレーター。カレンダーの制作をきっかけに、カード類やレターパックなど紙雑貨を作りはじめ、現在では雑誌や電子書籍、企業キャンペーンなど幅広いジャンルで活躍している。食べもの、生きもの、植物などさまざまなモチーフが描かれた、かわいいけれど甘すぎない、すっきりした大人っぽい印象の作品が人気。
kittari-hattari.com

Shoko Koseki
Illustrator whose works involve cut-paper and collage techniques. Inspired by producing a calendar, she began making paper-based products such as cards and letter-writing pads, her activities expanding widely to now include work for magazines, e-books, and corporate campaigns. Her cute but not overly sweet works featuring motifs the likes of food, creatures and plants are popular for their clearcut, mature impression.
kittari-hattari.com

聚落社

じゅらくしゃ

『なつかしくてあたらしいデザイン』をテーマに、型染めした和紙や生地を使った雑貨等を制作するブランド。染め職人でもある矢野マサヒコが、図案製作からデザイン染色、商品企画までを手がける。親しみのある身近なテーマを扱いながら、デザイン、染色の材料表現、柄の名前を聞いたときの言葉の響きなど、あらゆる方向から図案づくりにアプローチしている。

jyuraku-sha.jimdo.com

Jurakusha

Maker of products using stencil-dyed Japanese paper and fabric, based on the theme of "nostalgic, new design." Dyer Masahiko Yano handles everything from design of the patterns to dyeing and product planning. His approach considers design from multiple angles starting with the sense of being intimate and familiar, and including how the dyeing materials express themselves, and the words in the title resonate.

jyuraku-sha.jimdo.com

星燈社

せいとうしゃ

「日本の文化や精神性を今の暮らしに取り入れるきっかけづくり」を出発点にした雑貨メーカー。2009年創業。日本の伝統色を取り入れながらも今の暮らしにふつうに馴染む「あたらしくて普通の和柄」を提案している。2011年、東京都墨田区に直営店「星燈社本店」開店。2015年、学研教育出版より日本のえほんシリーズ『いきものなあに』『たべものなあに』を発売。

seitousha.jp
seitousha.ocnk.net

Seitousha

Maker of products that stem from the idea of "creating opportunities to incorporate Japanese culture and spirit into today's living." Established in 2009, Seitousha proposes "new and ordinary Japanese patterns" that incorporate traditional Japanese colors while adapting to everyday living today. Opened their flagship store in Tokyo's Sumida-ku in 2011, and in 2015 began publishing a picture-book series through Gakken starting with *What creature is this?* and *What food is this?*

seitousha.jp
seitousha.ocnk.net

関 美穂子
せき みほこ

2000年より京都の染色家堀江茉莉に師事し、型染めを始める。2008年に独立。以来、型染めの技法を使いながら、帯などの和装、広幅の布、和紙に染めたマッチラベル、染め絵など、さまざまな作品を制作している。オリジナル作品のほか、装画や挿絵、雑貨の図案も手がける。独自の世界観が広がる展示会にもファンが多い。

sekimihoko.exblog.jp

Mihoko Seki
Began studying stencil dyeing in 2000 under Kyoto dyer Mari Horie, launching her own practice in 2008. She has since produced a variety of works applying stencil dyeing techniques, including obi and other Japanese clothing, broadcloth, matchbox labels of dyed Japanese paper, and dyed pictures. In addition to her one-off works, she also creates bookcovers, illustrations, and designs for miscellaneous items. Exhibitions in which her unique worldview unfolds enjoy lots of fans.
sekimihoko.exblog.jp

1200年の京版画技術を継承する老舗・竹中木版がプロデュースする、伝統とモダンを融合させたデザインが特徴の木版雑貨ブランド。竹中木版の5代目摺師であり竹笹堂代表・竹中健司とその弟子6代目摺師・原田裕子は、国内外のアーティストとのコラボレーション制作やワークショップなど木版技術の振興とともに新しい試みを意欲的に行う。機械印刷が主流の中、職人が1枚ずつ手摺りする和紙は使うほどに独特の風合いが増す。

www.takezasa.co.jp

竹笹堂
たけざさどう

Takezasado
A woodblock-print brand characterized by design that blends the traditional and modern, produced by Takenaka Mokuhan, the woodblock printing studio successors to Kyoto's 1200-year history of woodblock printing techniques. The fifth-generation Takenaka Mokuhan printer and director of Takezasado, Kenji Takenaka, and his pupil, sixth generation printer Yuko Harada collaborate with other Japanese and international artists and hold workshops through which they promote traditional woodblock printing techniques while actively experimenting. Sheet-by-sheet handprinting by craftspeople on washi paper adds to the distinctive texture of their products.
www.takezasa.co.jp

nanoca design
遠藤澄子 ナノカ デザイン
えんどうすみこ

「日本の良いところをカタチに」をテーマに、グラフィックデザイン・商品開発・ショッププロデュースなどを手がける小さなデザイン事務所。今日（こんにち）と和を繋ぐものづくりのプロジェクト『connichi＋WA project(こんにちわプロジェクト)』を立ち上げ、江戸時代から続く老舗和菓子店や京染和紙職人と商品開発を行う。オリジナルプロダクトは「スパイラルマーケット」「スーベニアフロムトーキョー」などで販売中。

nanocadesign.com
nanocadesign.stores.jp

nanoca design / Sumiko Endo
A small design office engaged in graphic design, product development and store production that takes as its theme "giving form to what's good about Japan." Launched the connichi+WA project, linking things Japanese with today, developing products in conjunction with a longstanding Japanese sweets shop established in the Edo period and Kyoto stencil dyers. Their products are sold at such venues as Spiral Market and Souvenir from Tokyo.

nanocadesign.com
nanocadesign.stores.jp

榛原
はいばら

創業以来200年間にわたり、東京日本橋を中心に和紙及び紙製品の販売を行っている老舗和紙店。全国に残る良質の和紙を材料に、意匠を凝らした金封、便箋、和小物を加工販売している。中でも明治期にデザインされたオリジナルの千代紙を用いた小物類は、華やかなデザインとあたたかみのある色合いで人気。

www.haibara.co.jp

Haibara
Washi and paper product merchants based in the Nihonbashi district of Tokyo for more than 200 years. Haibara sells money envelopes, letter paper, and Japanese-style paper products that they produce from the finest washi available in Japan and decorate with their own designs. Among these, the paper accessories made with original chiyogami designed in the Meiji period are popular for their colorful designs and feeling of warmth.

www.haibara.co.jp

水縞
みずしま

水玉好きのデザイナーと縞々好きの文具店店主が、2006年、東京吉祥寺に小さく立ち上げた文房具ブランド。異国で見つけた素敵素材や日本で見つけた職人技術など、ふたりの目線を通して製作、セレクトする、すこしビターな文房具が人気。水玉担当：プロダクトデザイナーの植木明日子。縞々担当：文房具店36 Sublo(サブロ) 店主 村上 幸。

mzsm.jp

Mizushima
A designer who loves polka dots and the manager of a stationery store who loves stripes joined forces in 2006 to launch a stationery brand on a small scale from Tokyo's Kichijoji district. Merging their two perspectives in such things as materials found overseas and craftsmanship from Japan, the stationery items they produce and select are popular for their little twists.

mzsm.jp

100枚レターブック 和もよう

2016年3月12日　初版第1刷発行
2016年9月16日　　　第2刷発行

編著　PIE BOOKS

デザイン　公平恵美（PIE Graphics）
カバーイラスト　小関祥子
翻訳　パメラミキ
編集　長谷川卓美

発行人　三芳寛要

発行元　株式会社パイ インターナショナル
〒170-0005　東京都豊島区南大塚2-32-4
TEL 03-3944-3981　FAX 03-5395-4830
sales@pie.co.jp

印刷・製本　アベイズム株式会社

100 Papers with Japanese Patterns
Designed by 12 Japanese Artists

Written and edited by PIE BOOKS
Design : Emi Kohei (PIE Graphics)
Cover illustration : Shoko Koseki
English translation : Pamela Miki
Editing : Takumi Hasegawa
PIE International Inc.
2-32-4 Minami-Otsuka, Toshima-ku,
Tokyo 170-0005 JAPAN
sales@pie.co.jp

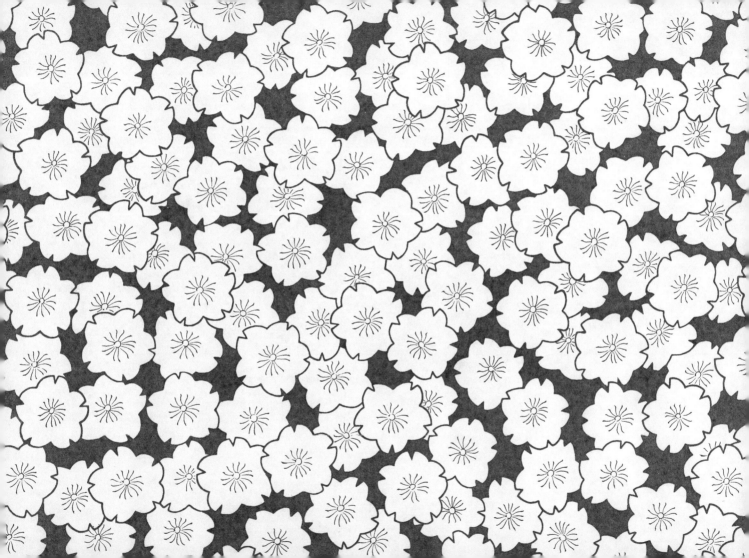

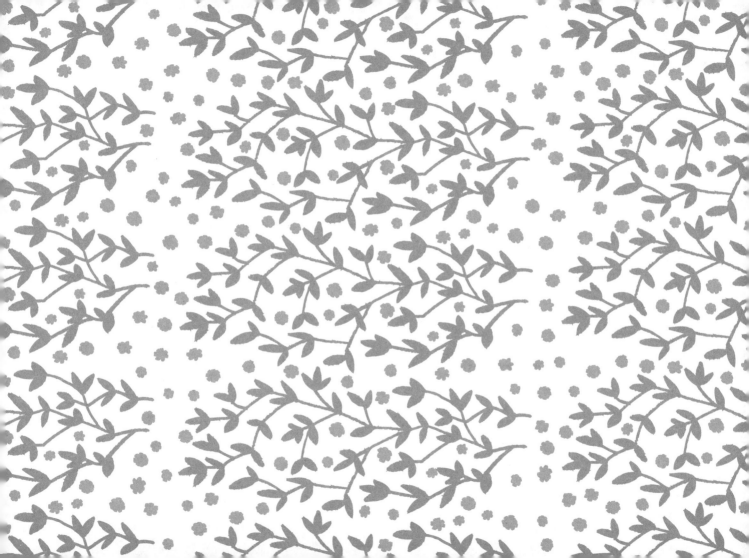

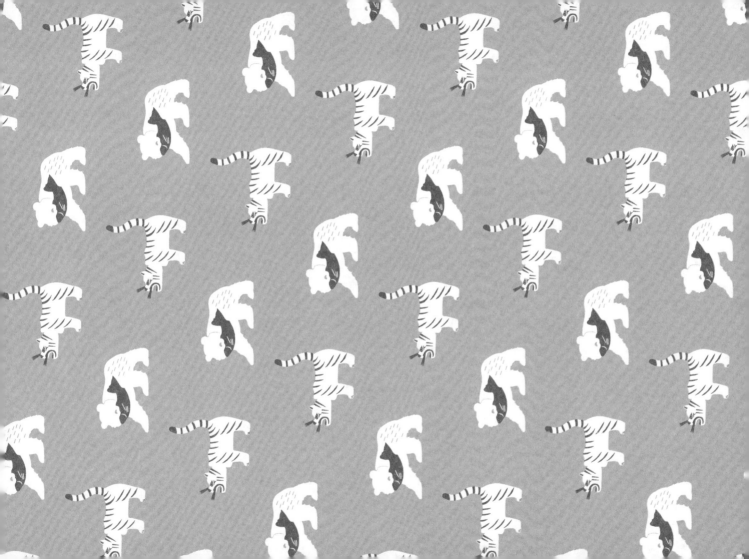

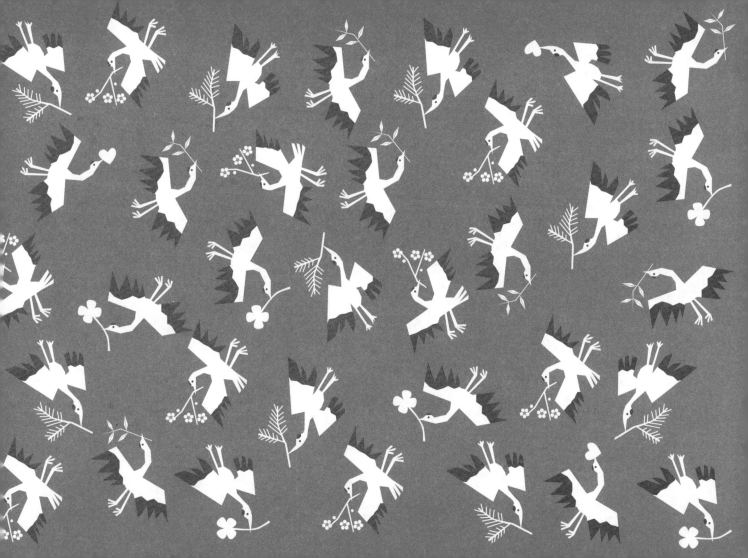

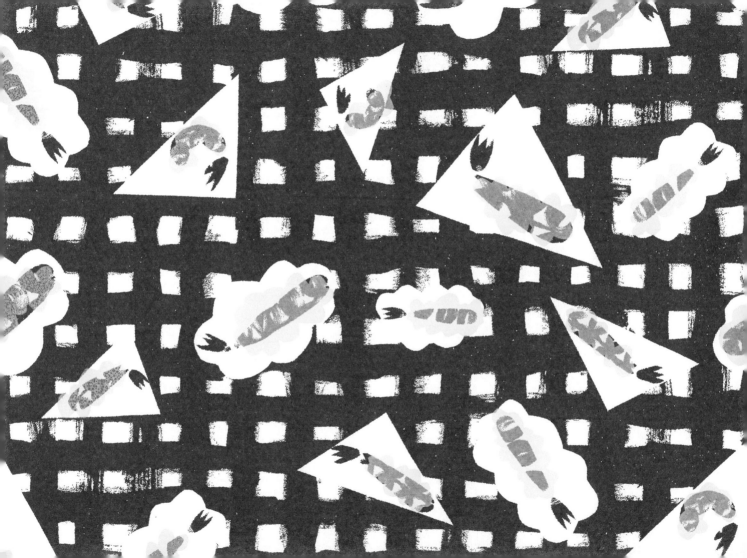

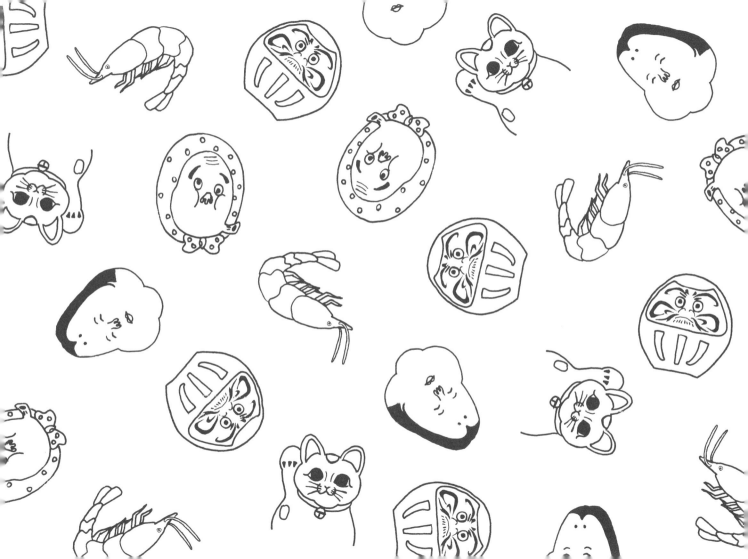

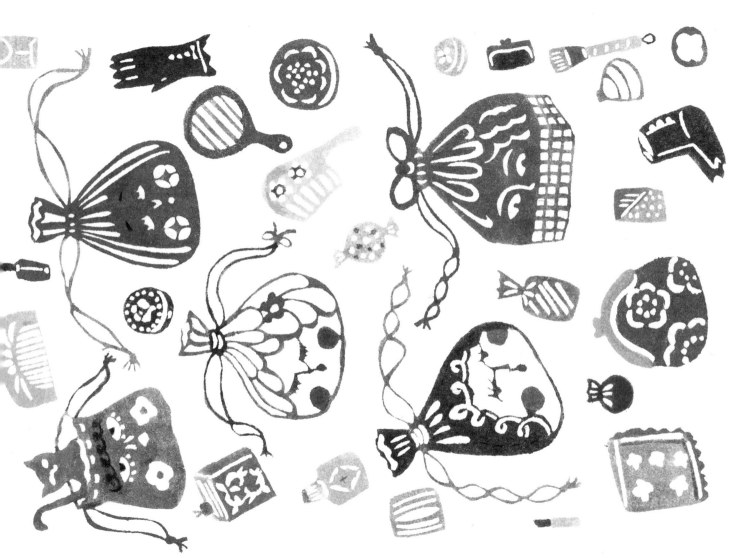

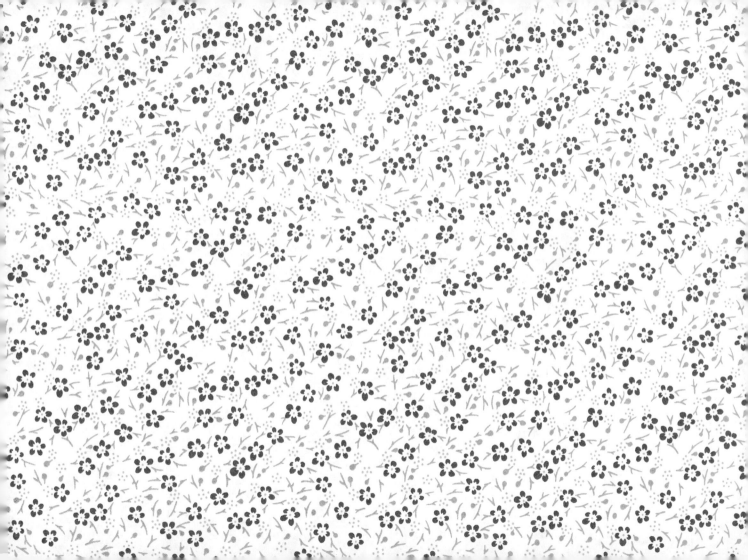

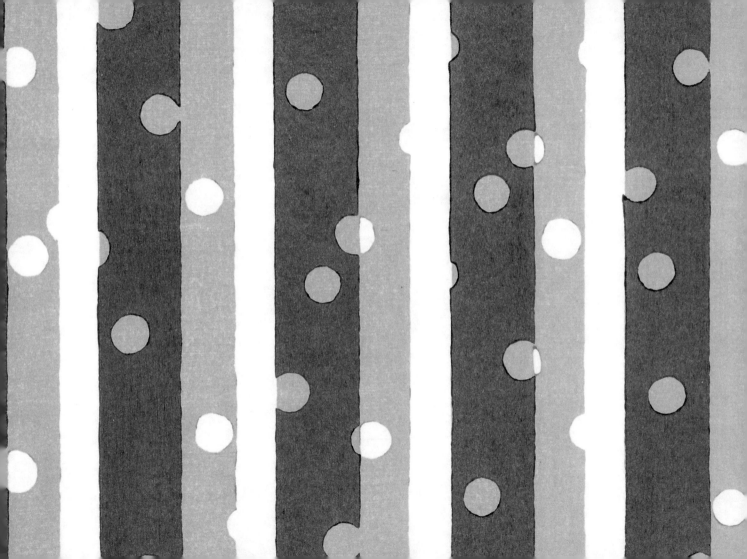

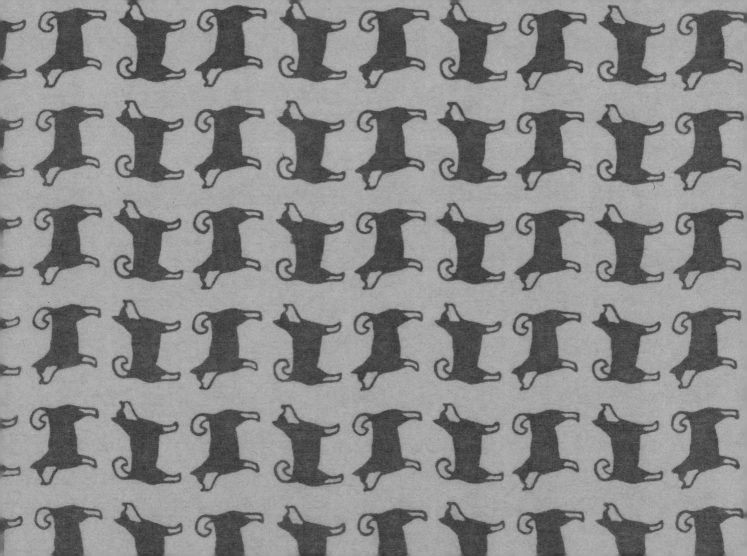

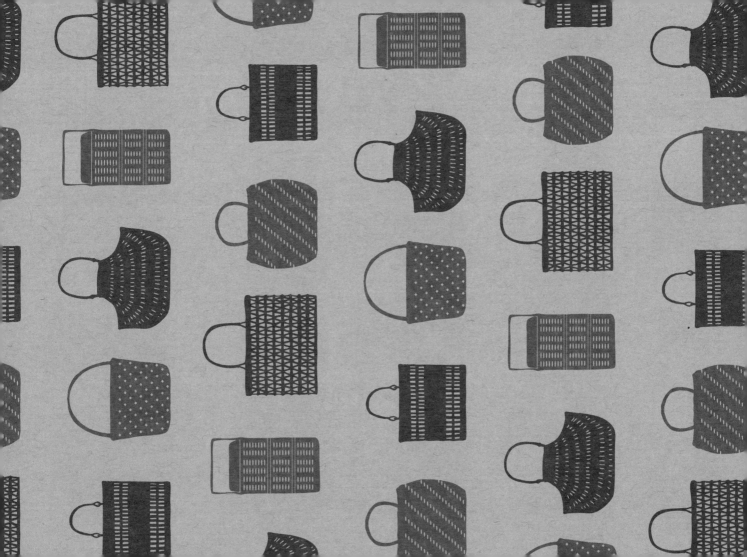

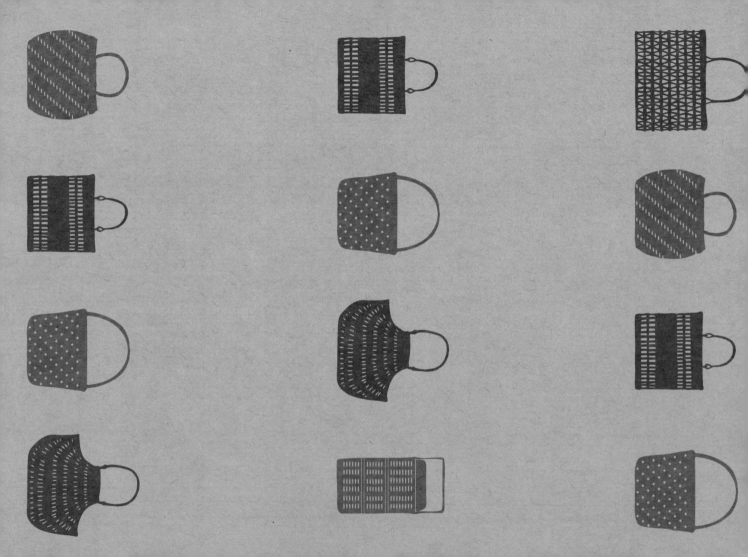

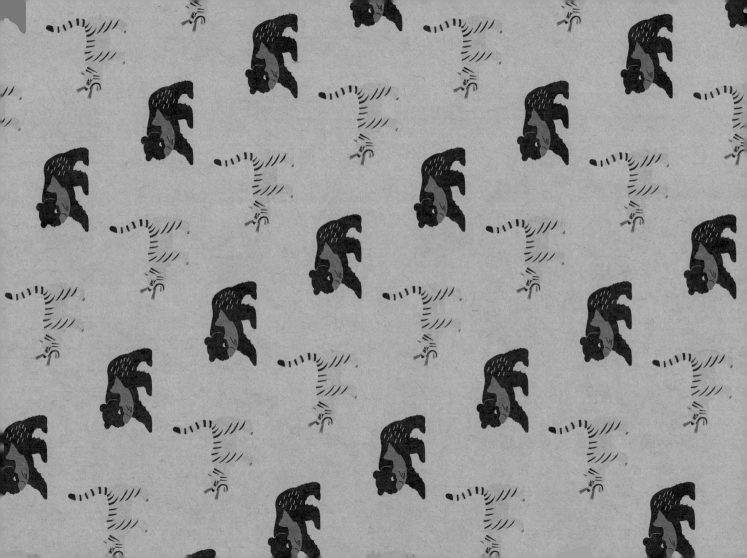

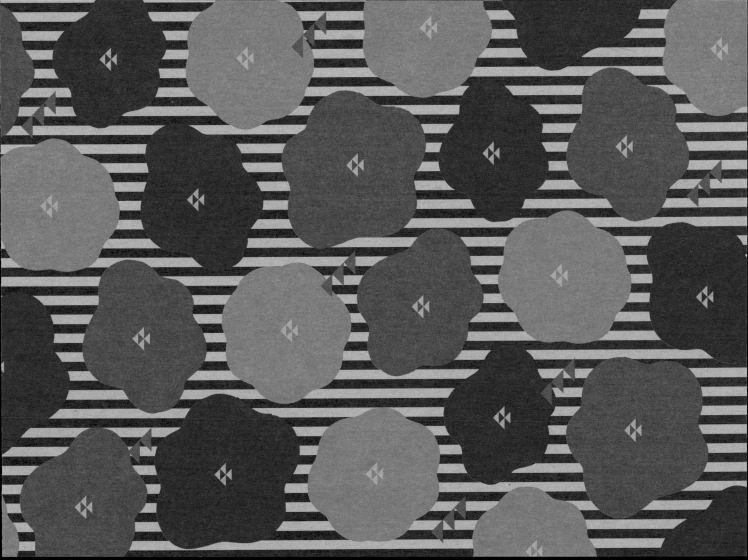

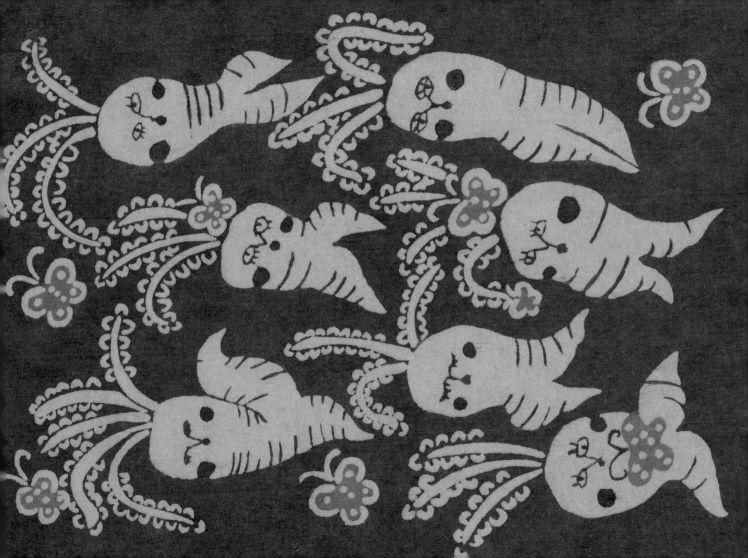

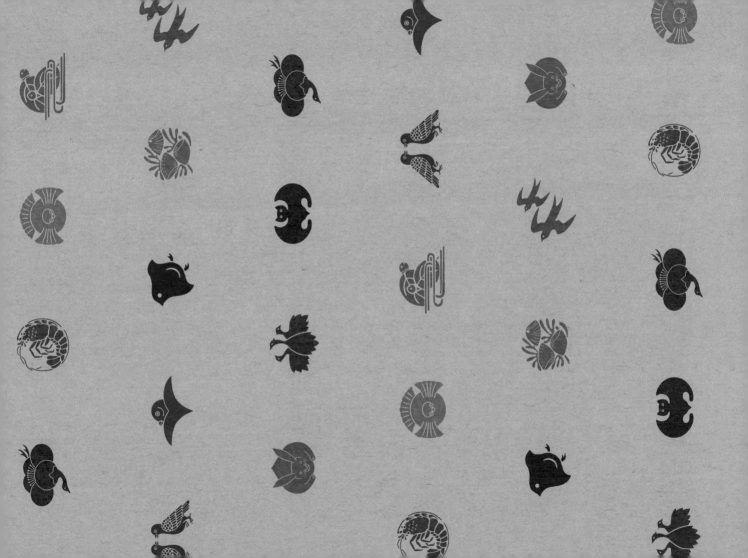

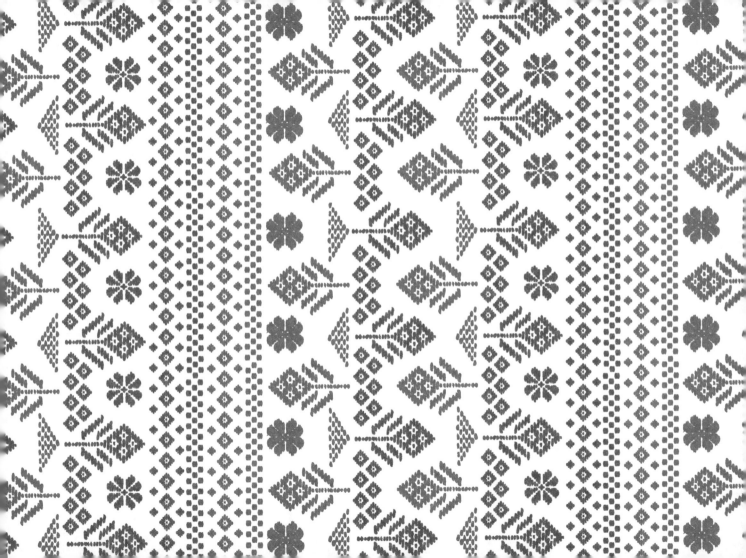

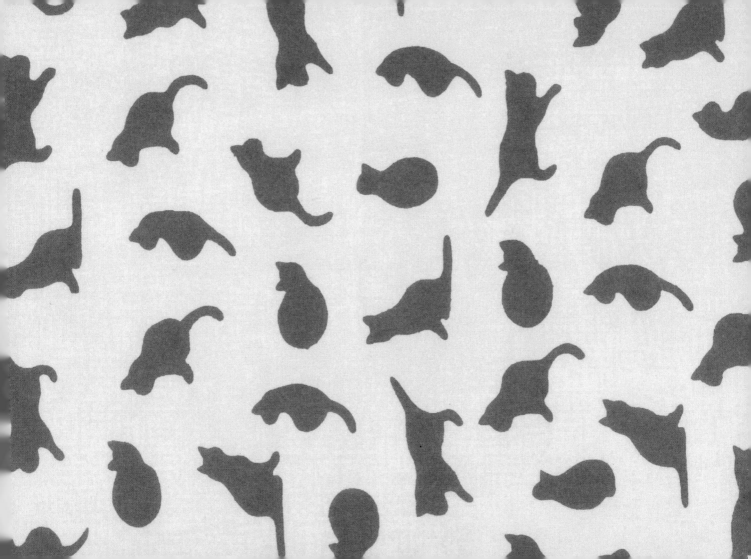

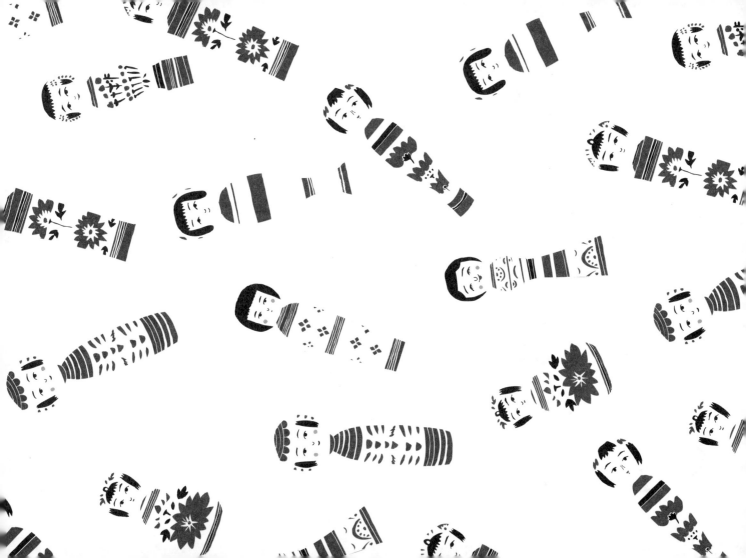

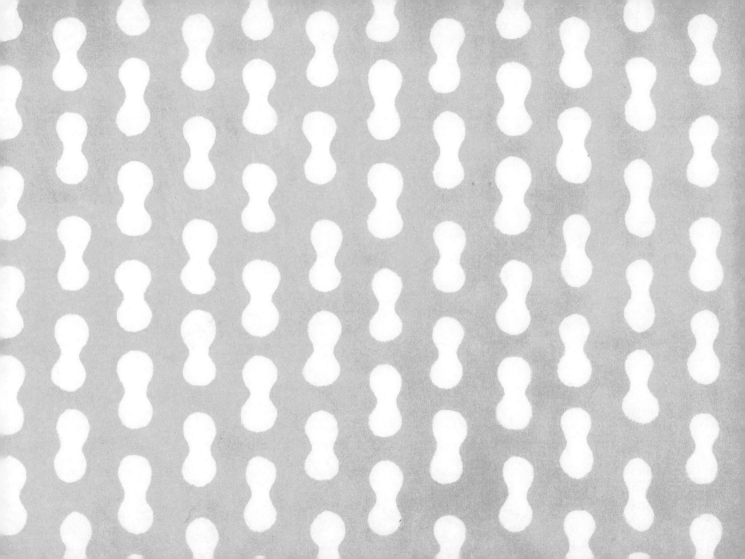

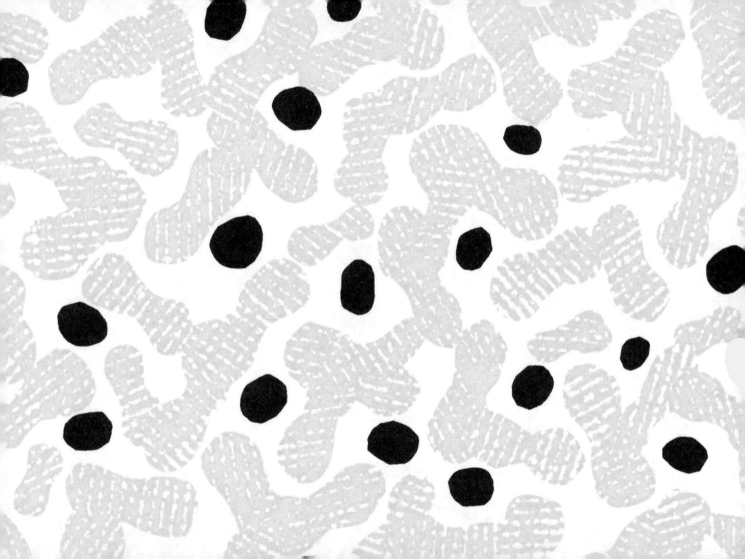

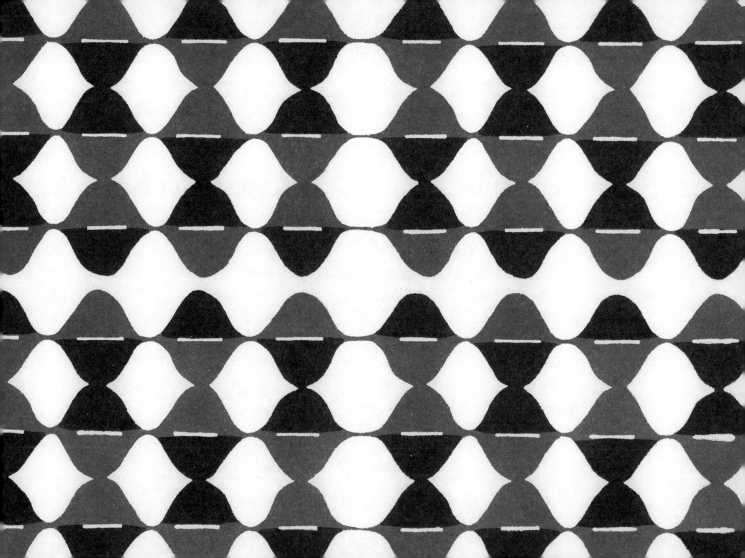

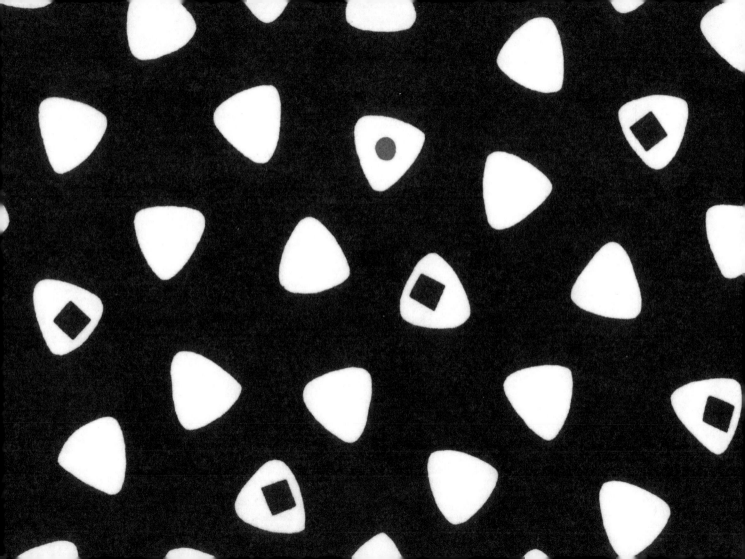

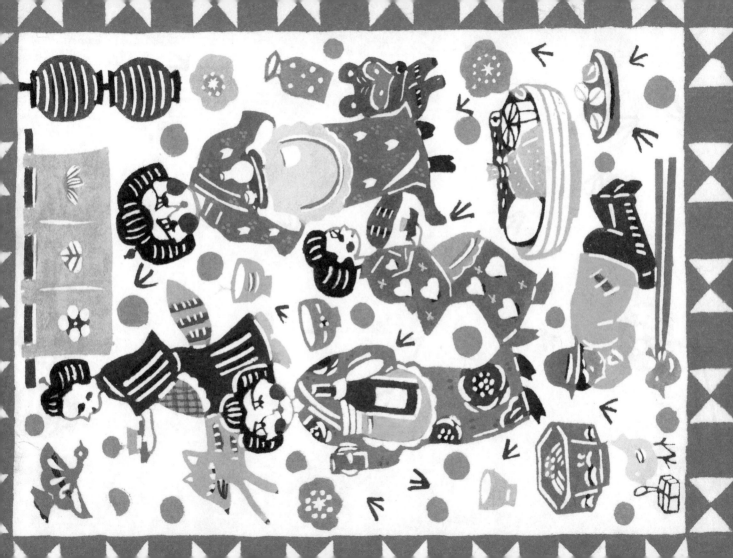

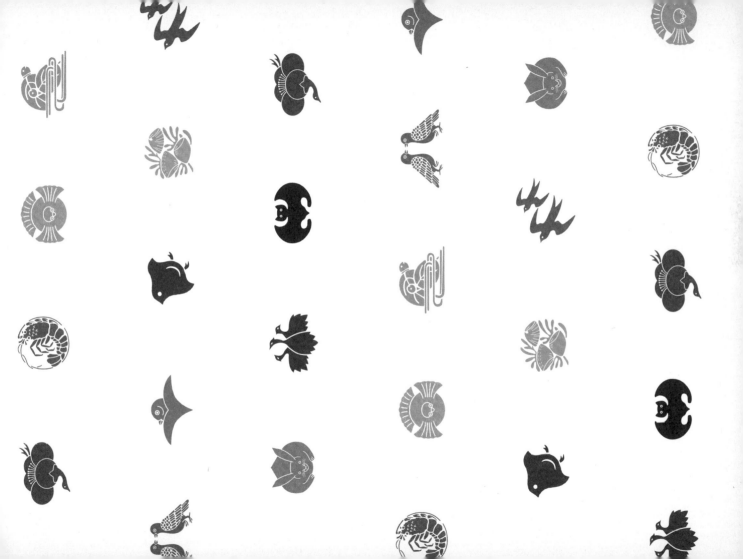

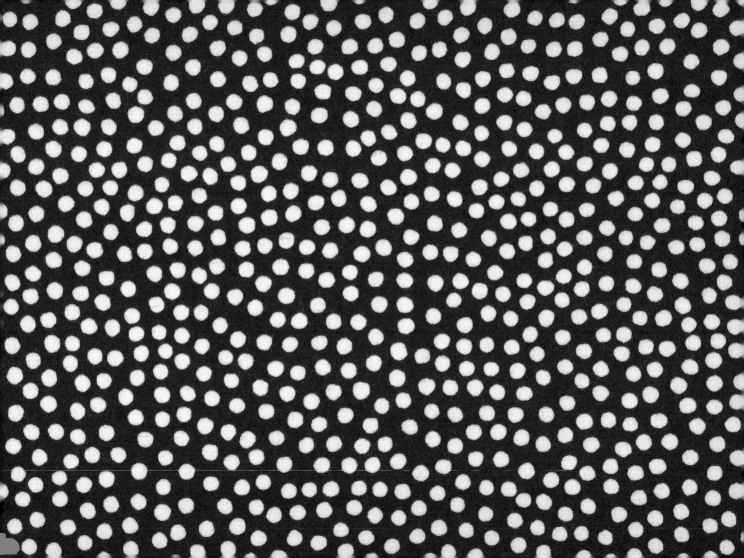

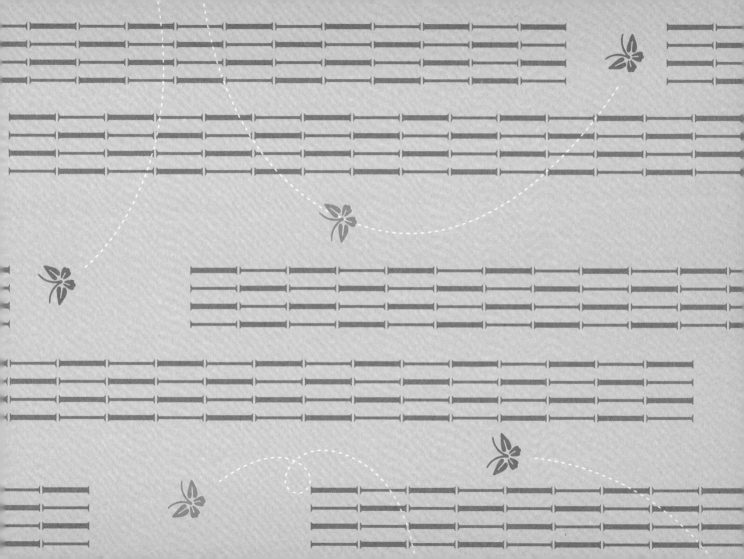

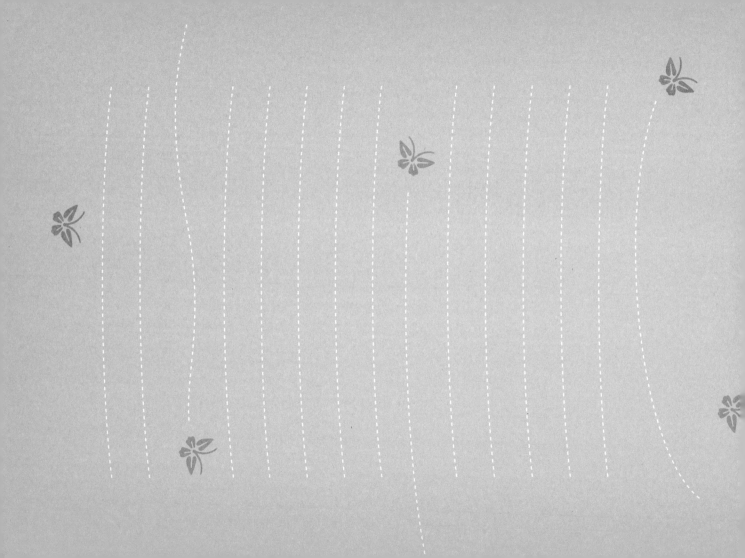

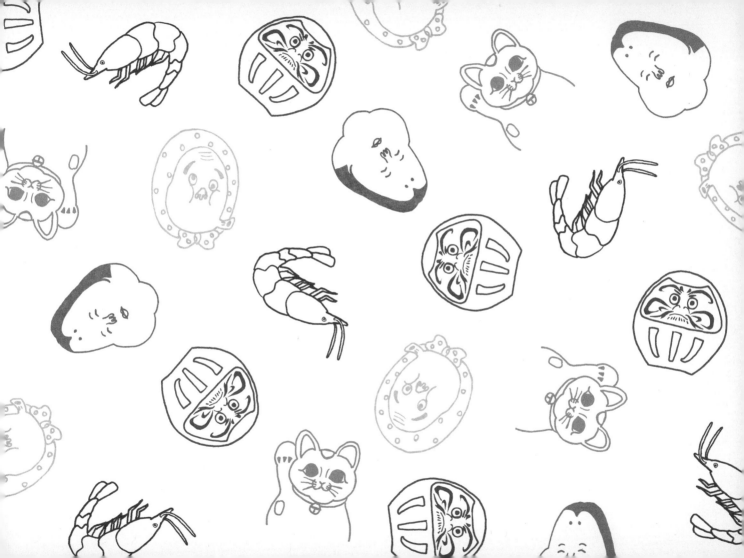

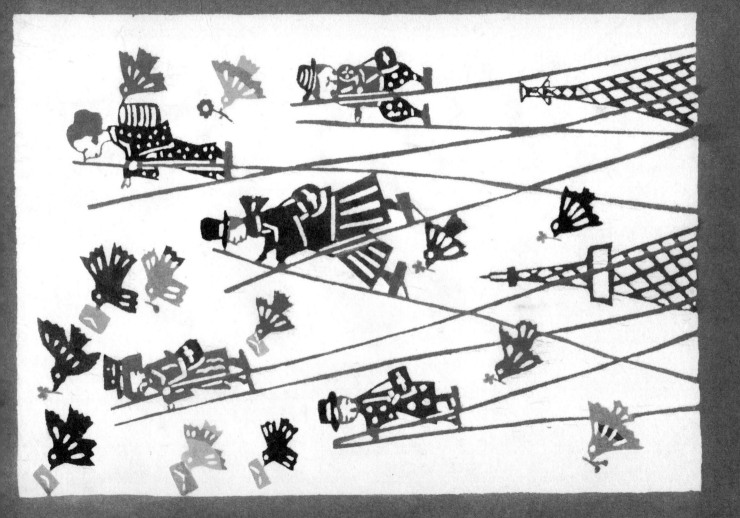

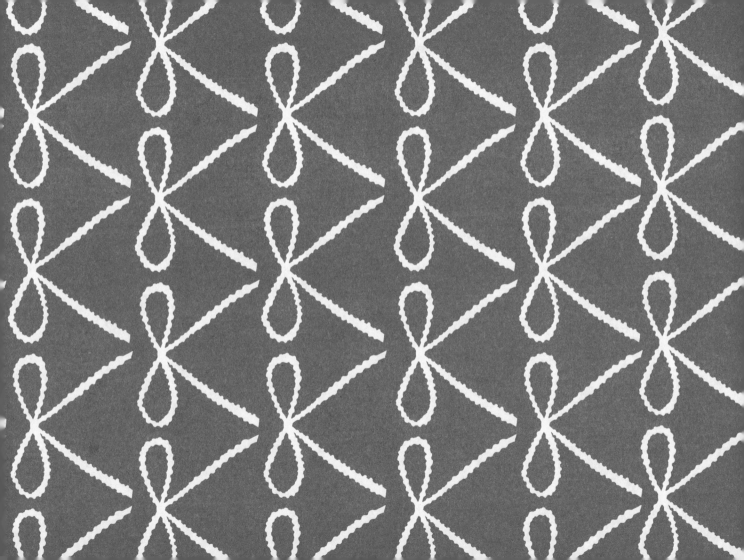

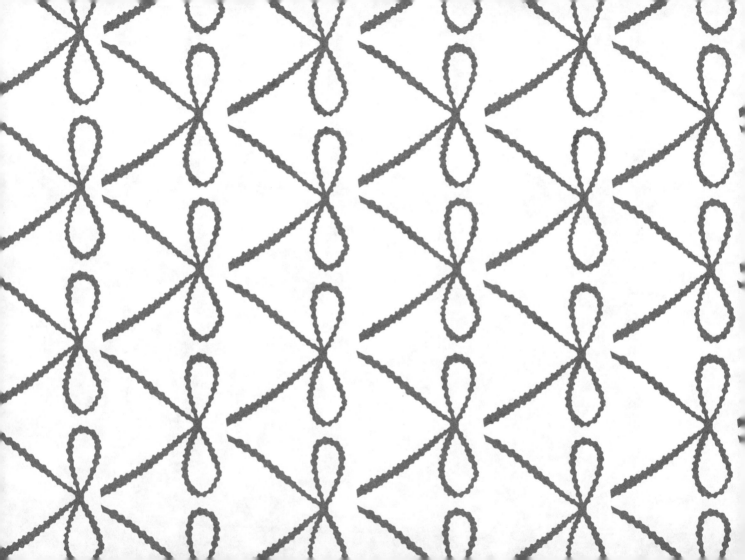

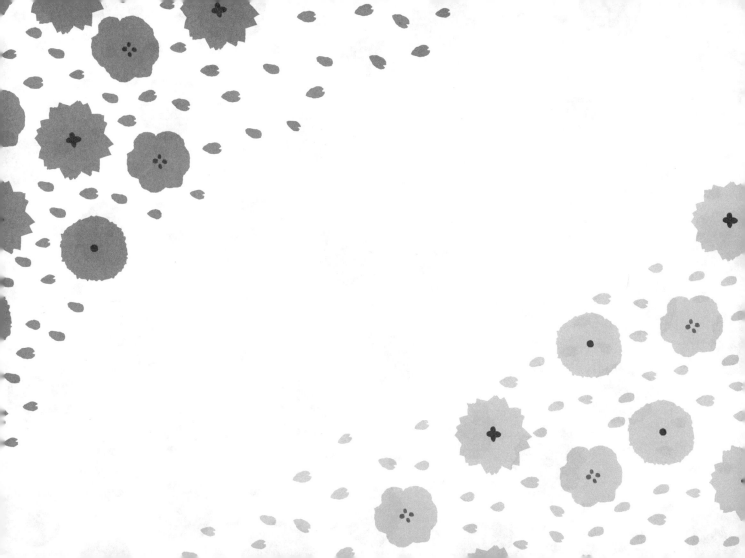

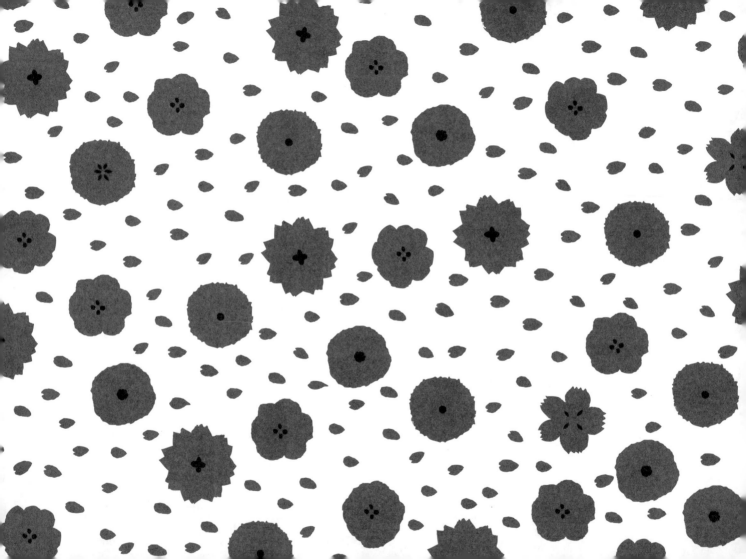

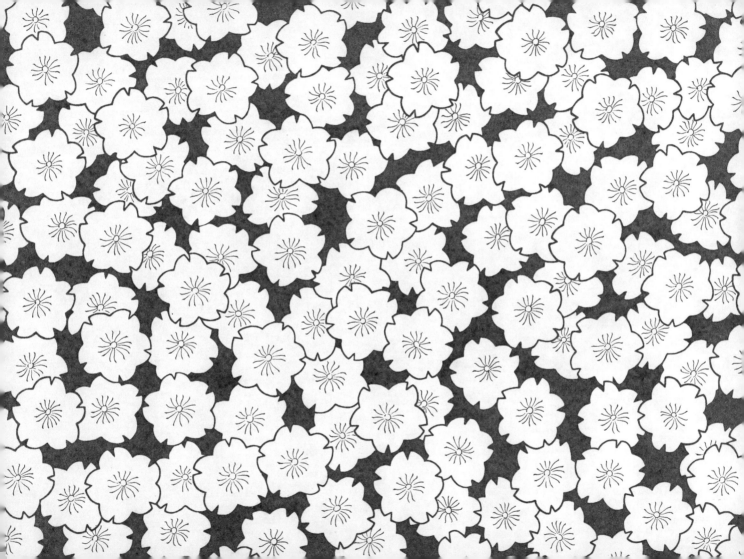

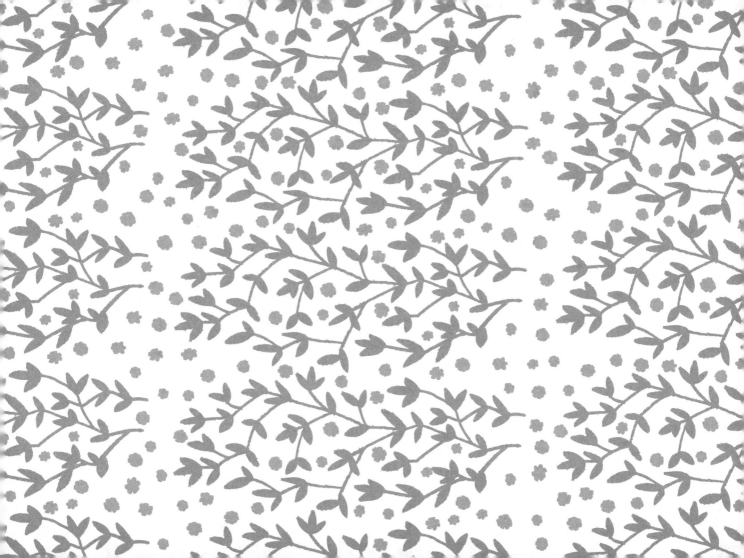

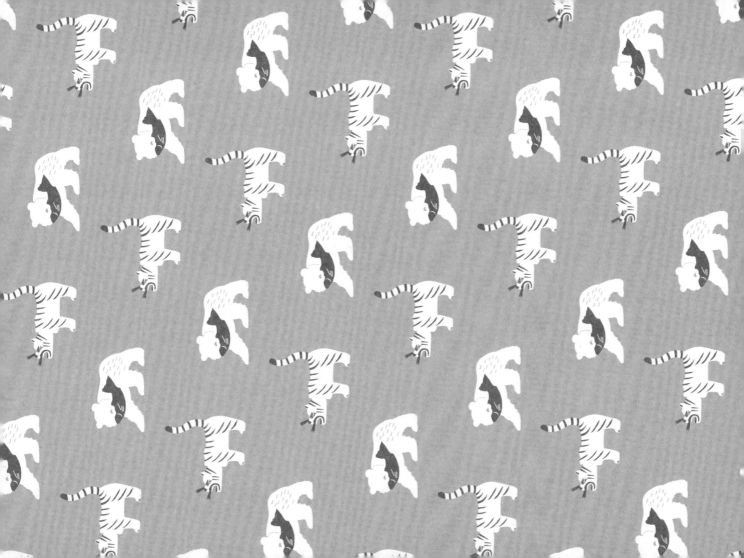

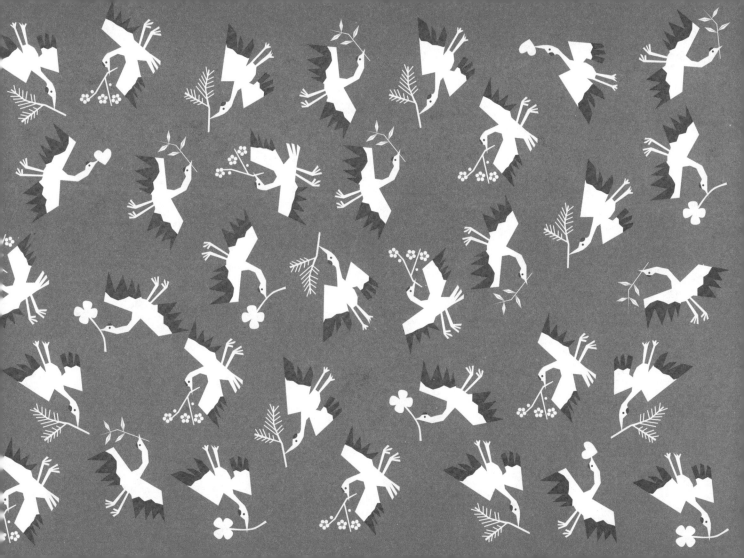

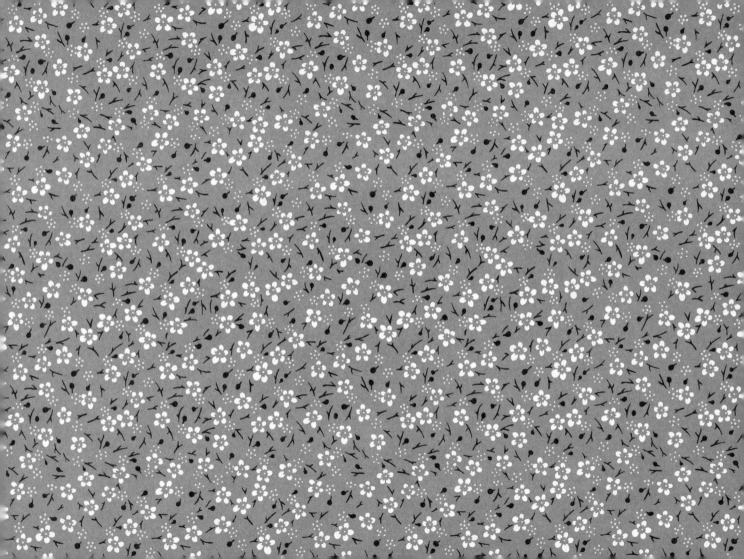

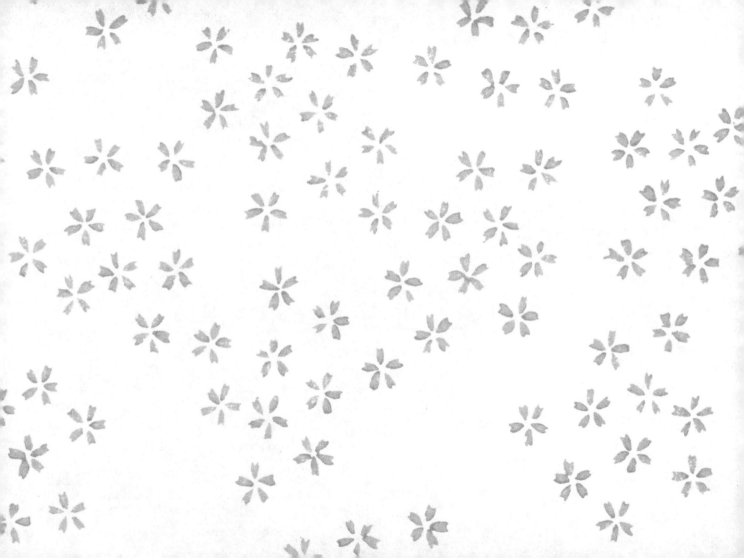

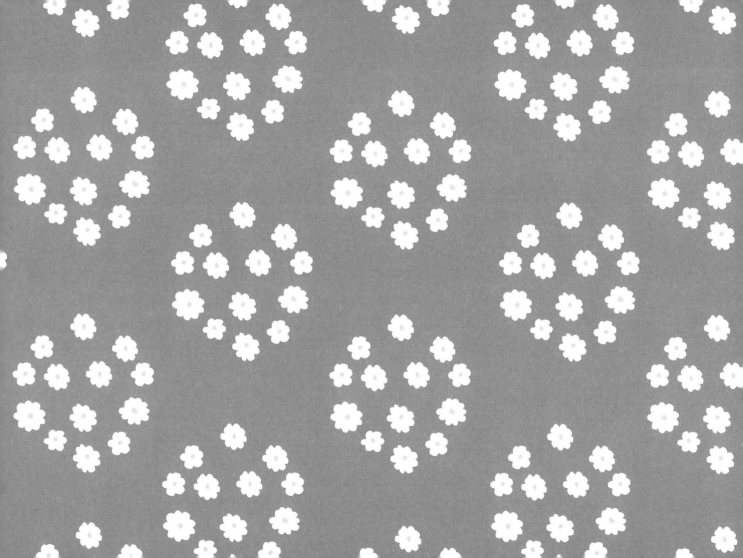

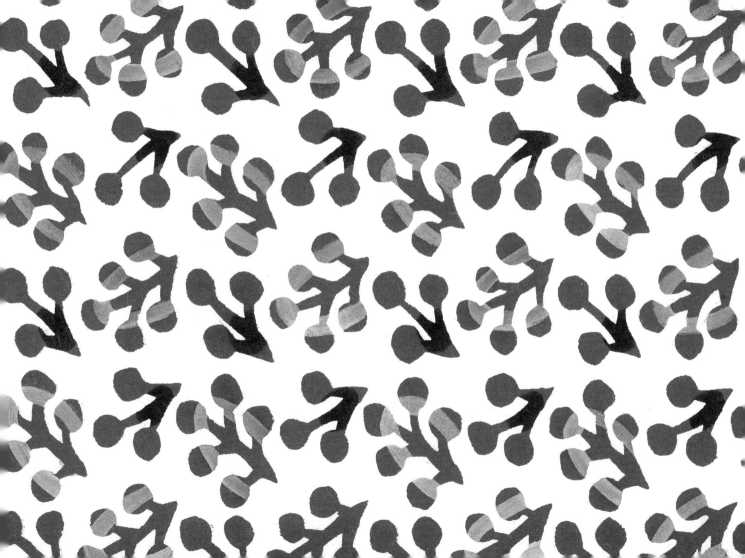

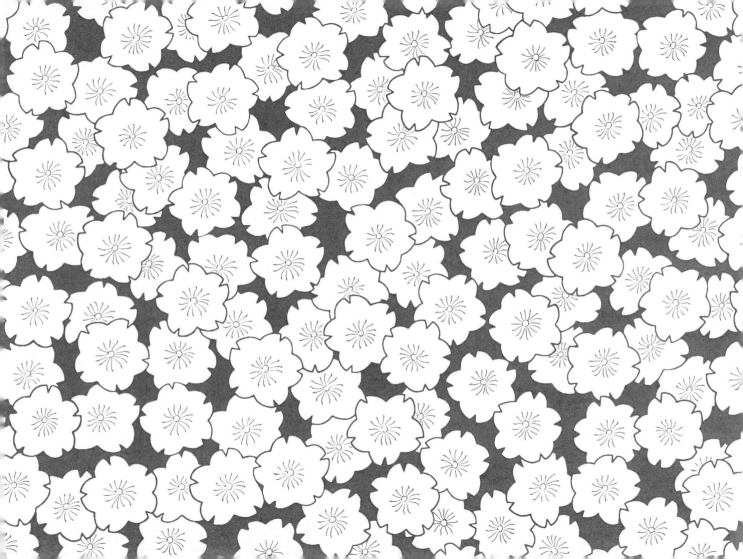

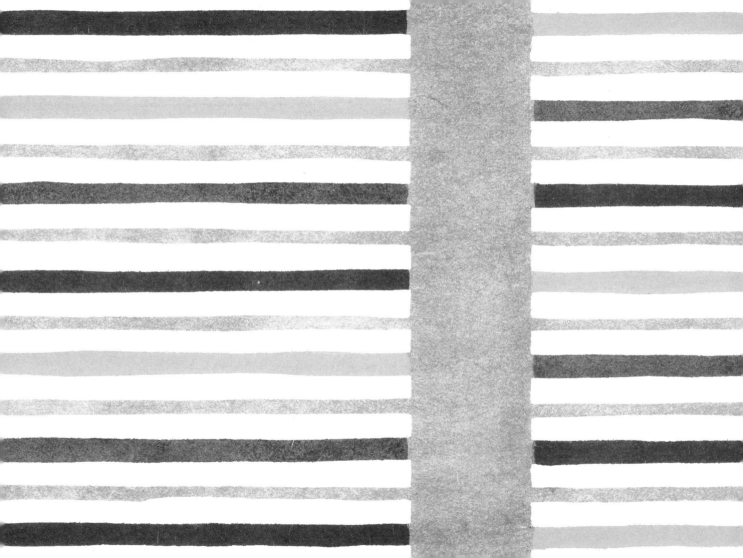

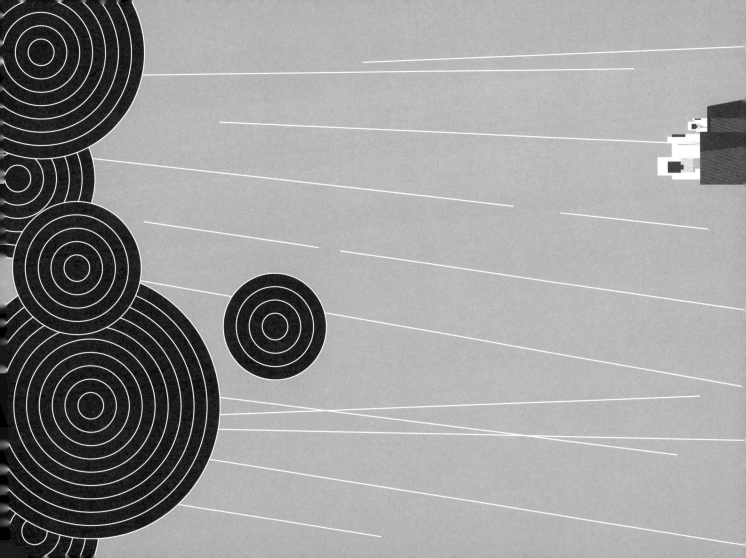

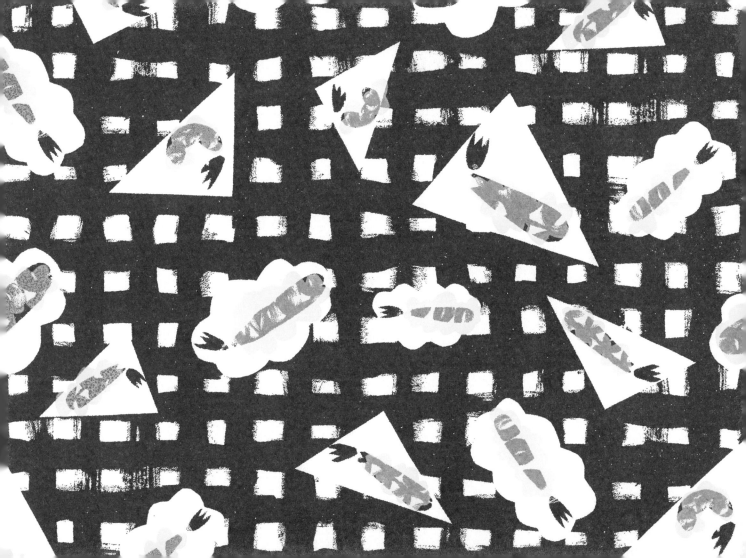

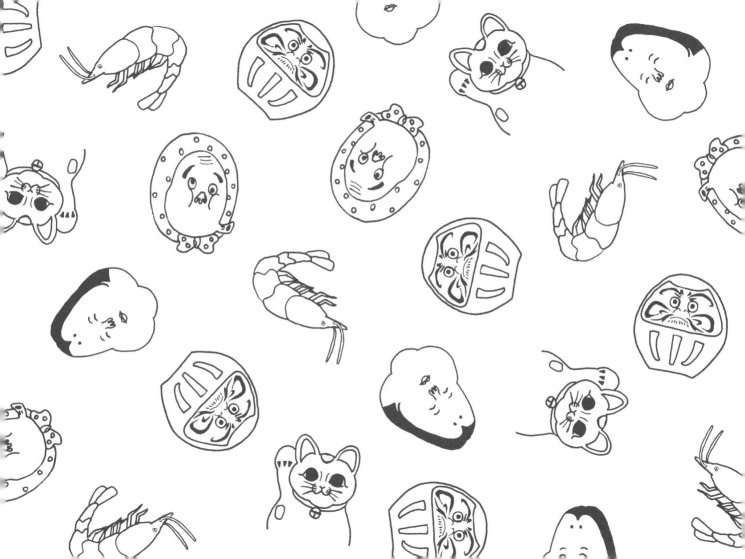

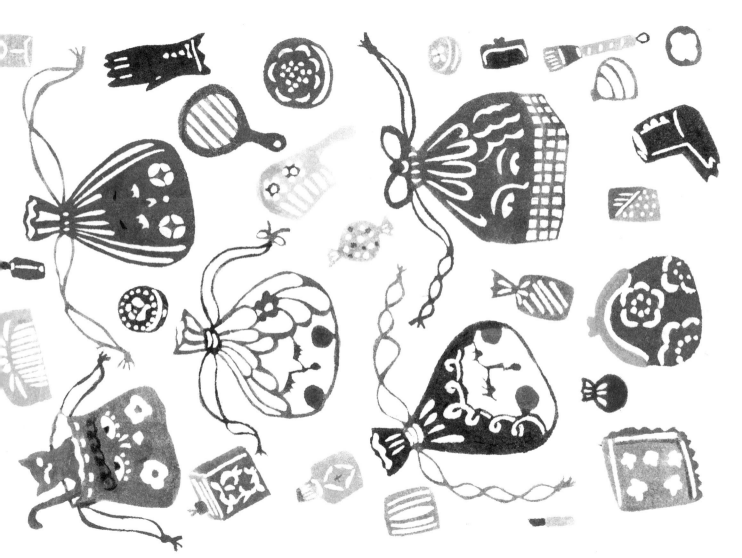

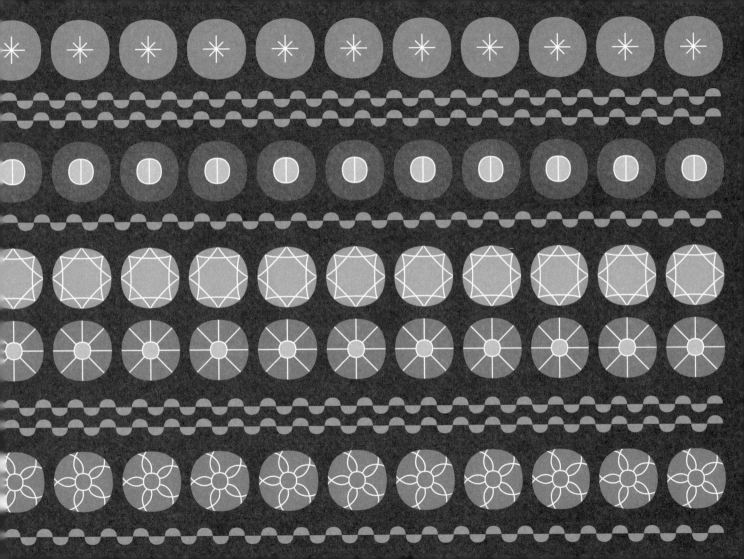

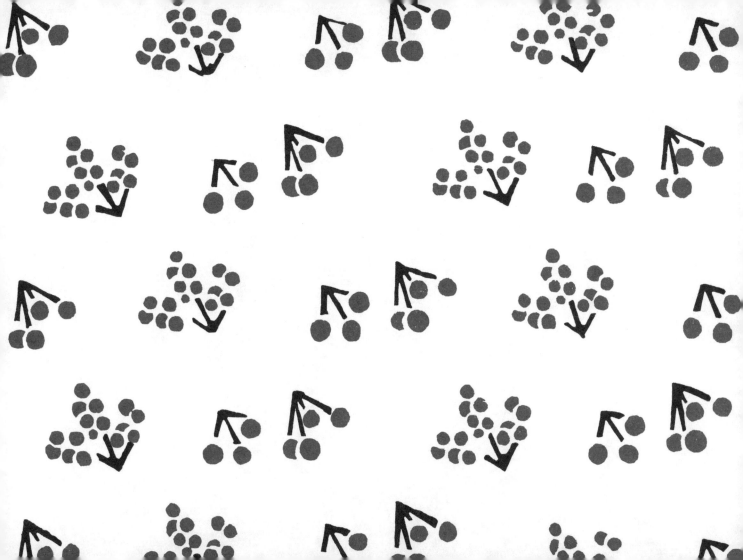

2

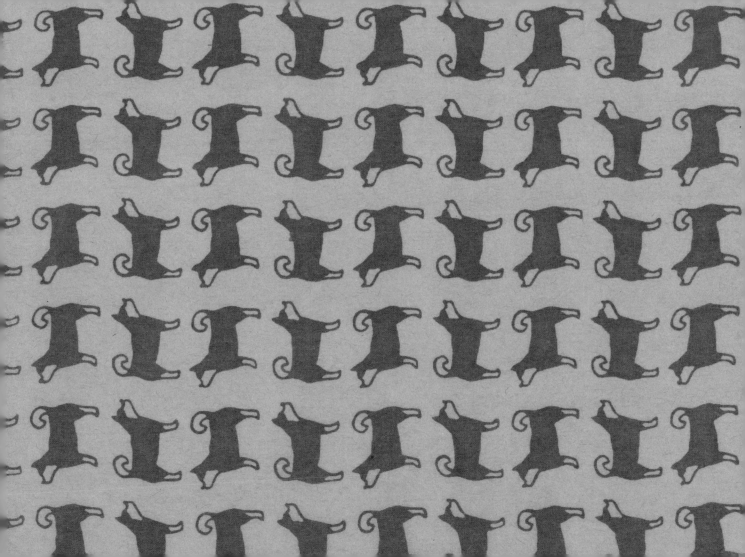

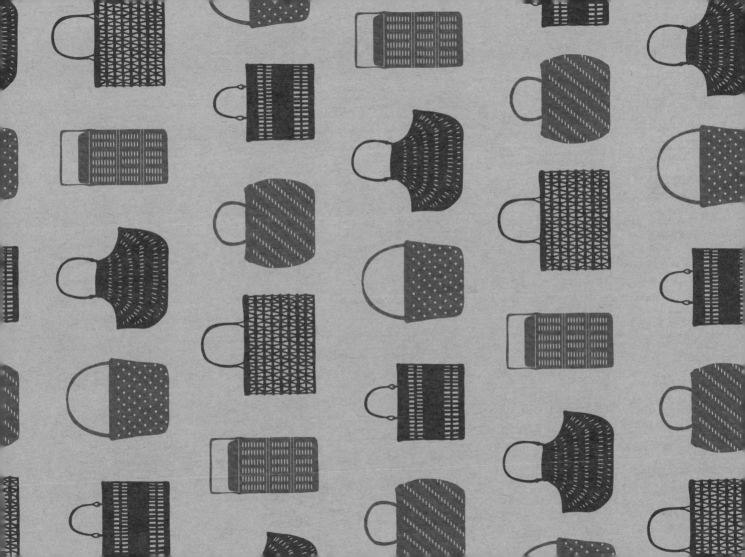

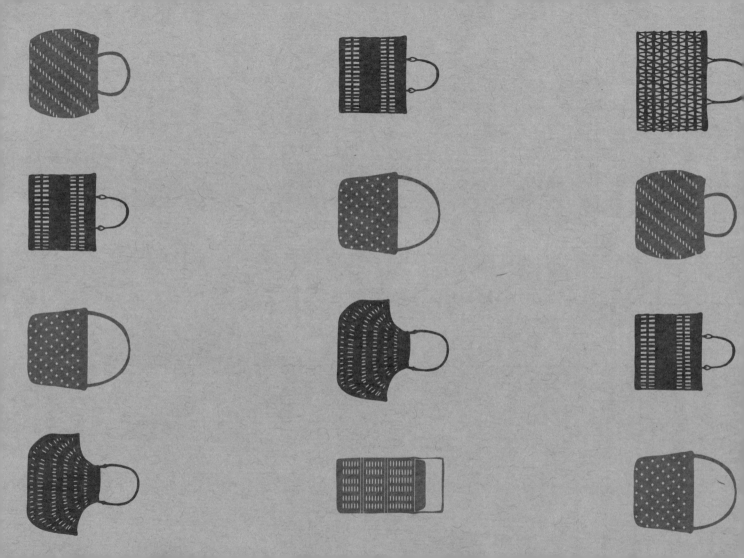

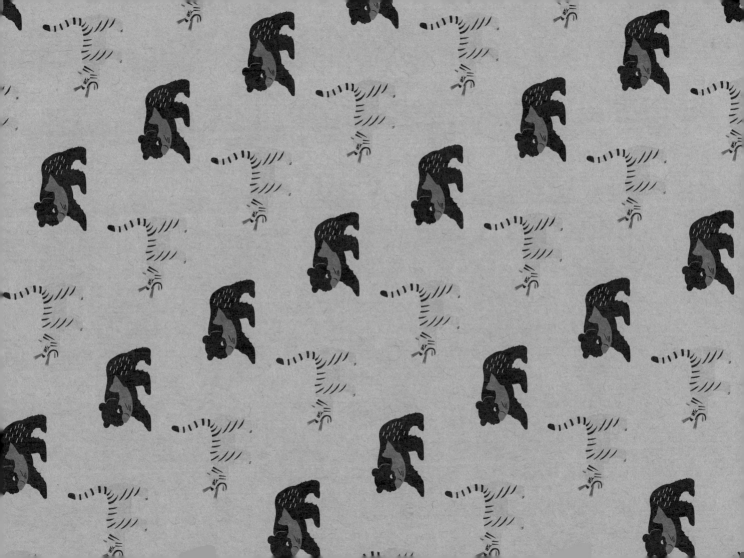

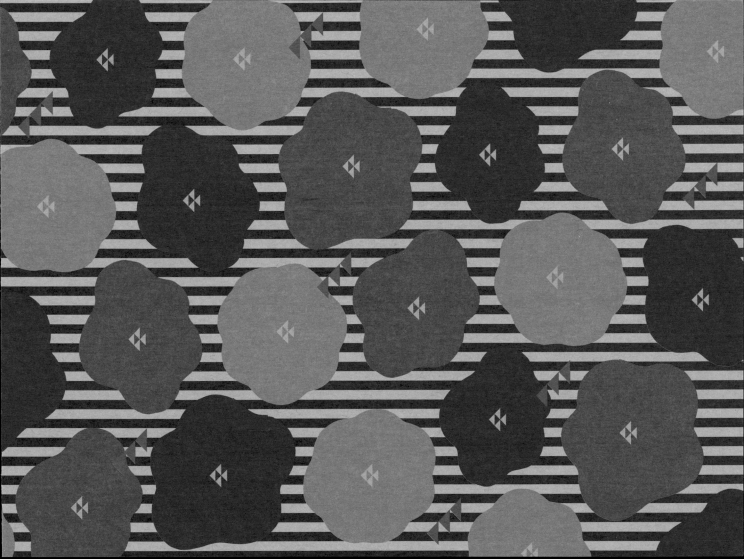

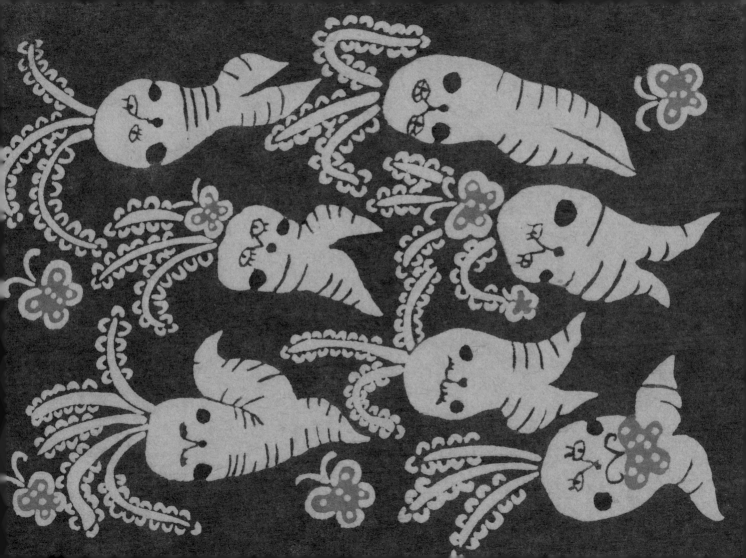

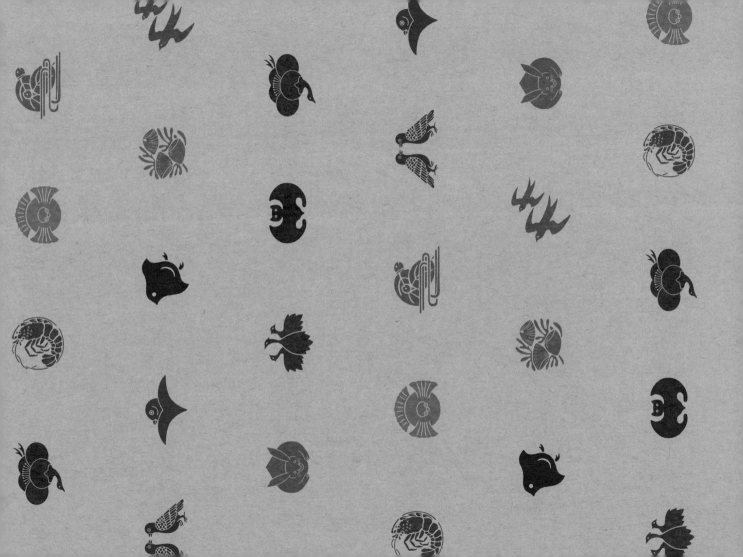

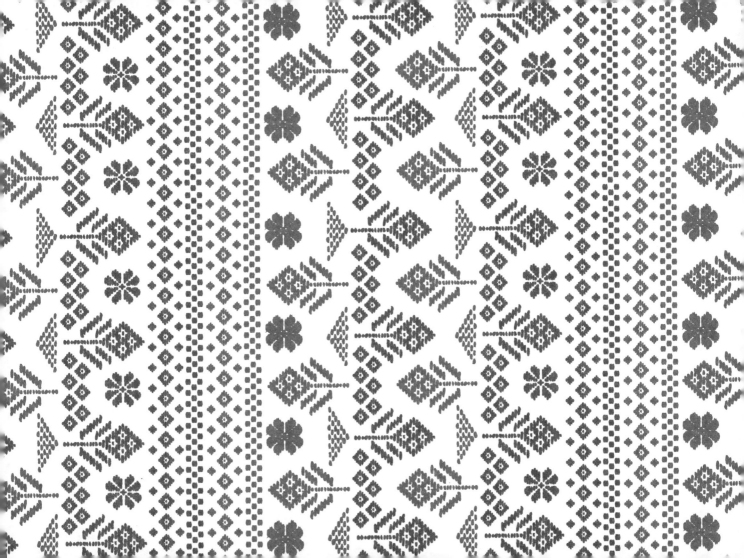

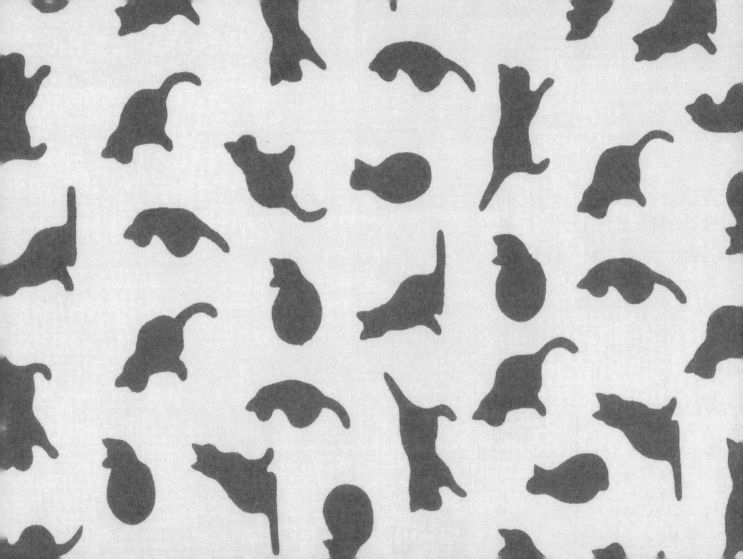

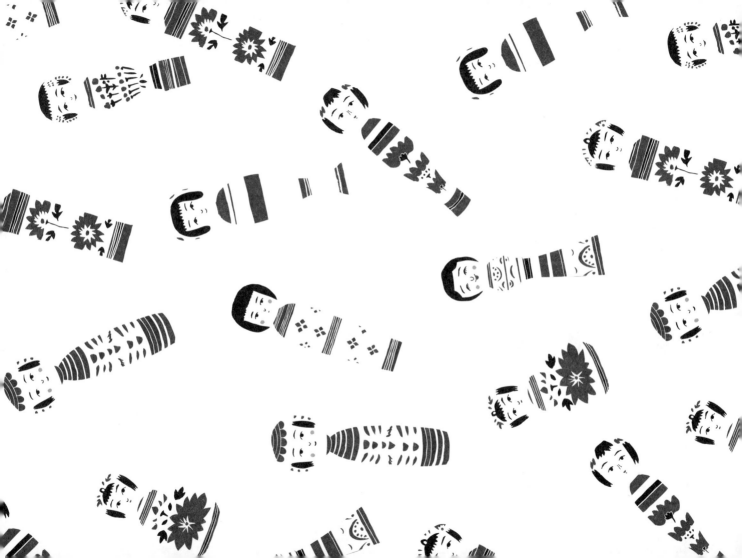

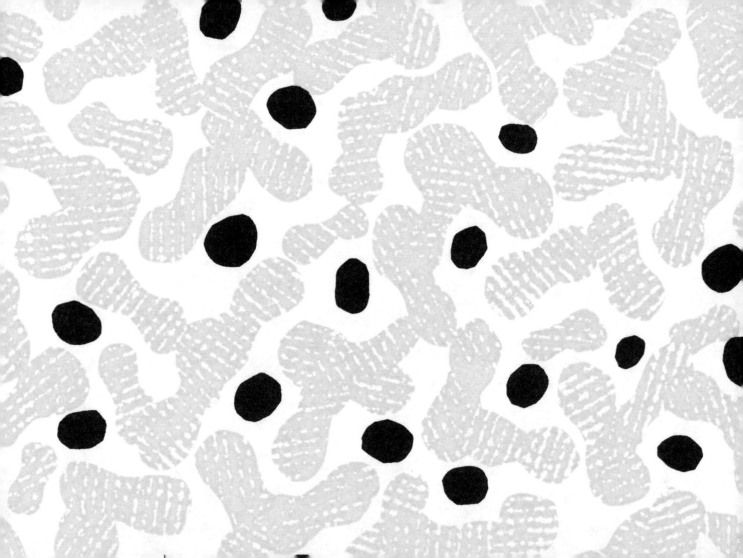

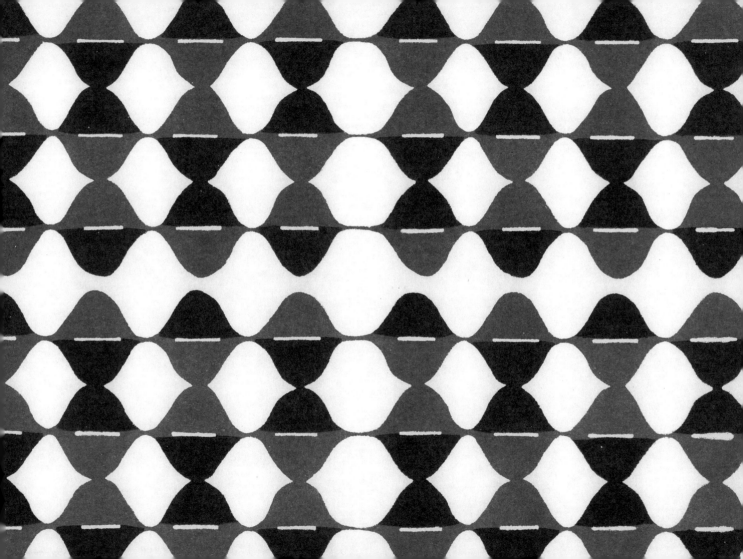

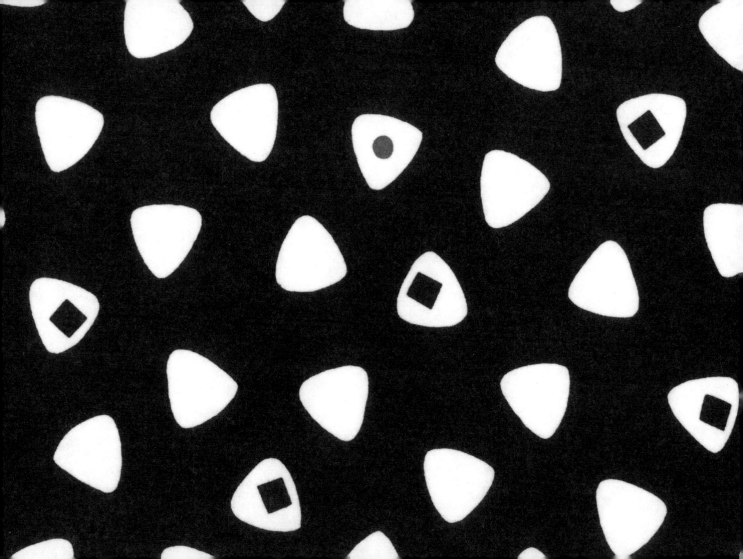

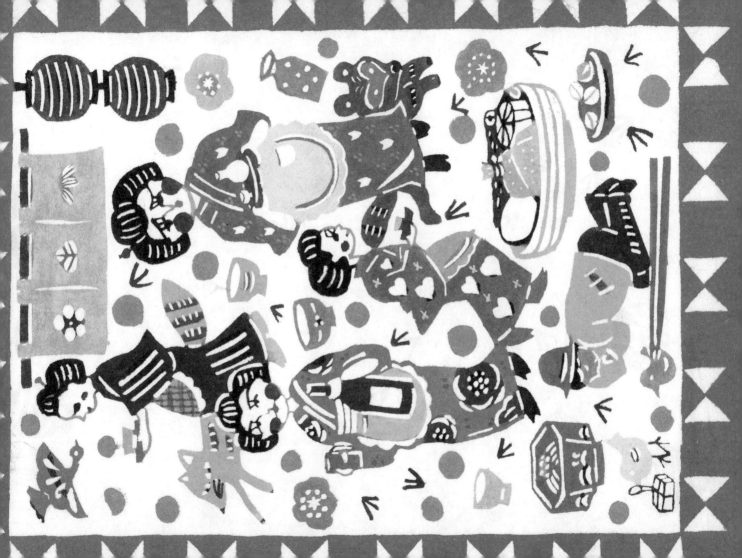

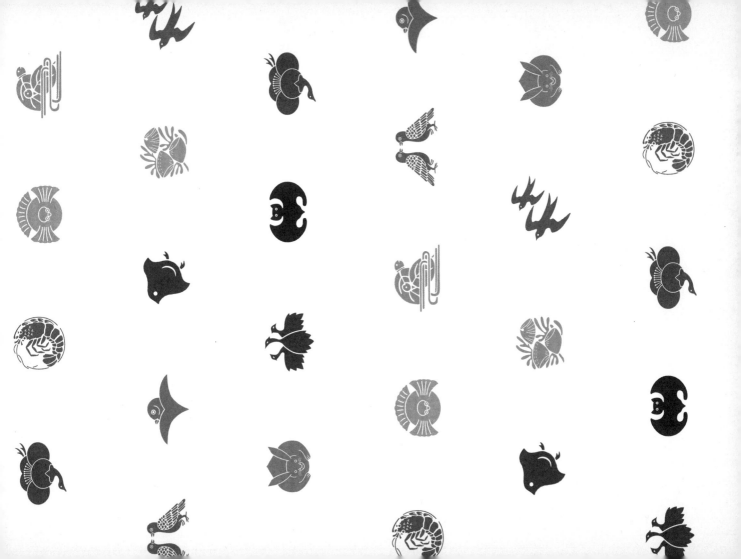

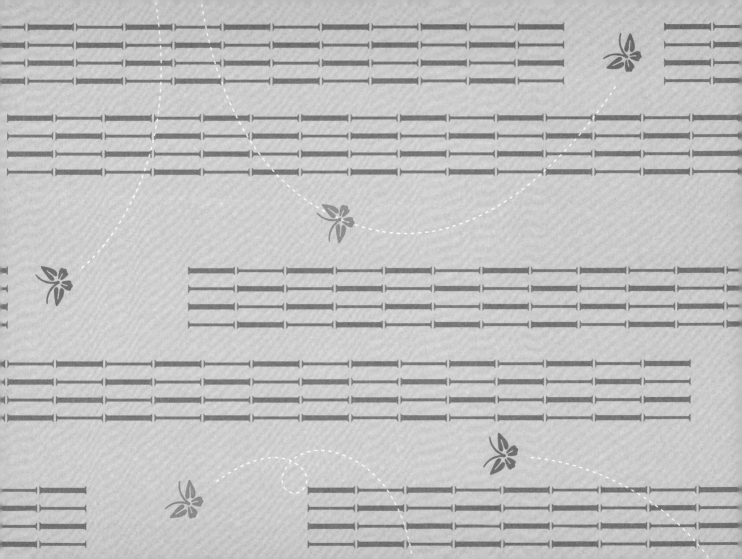

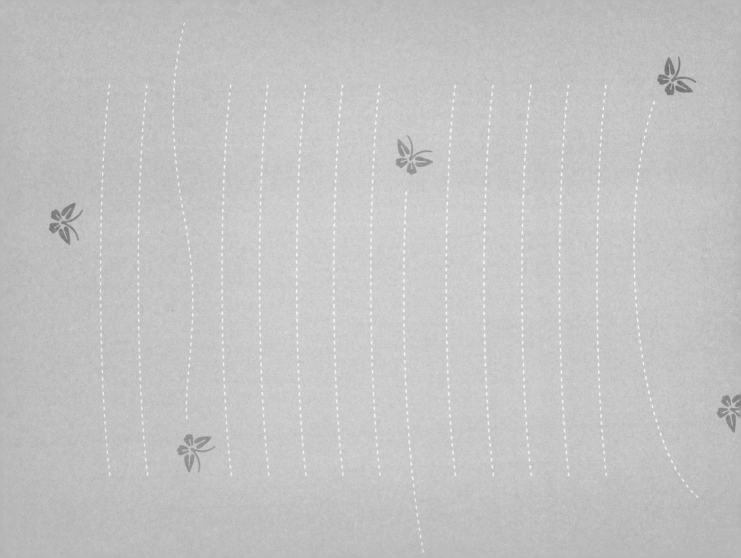

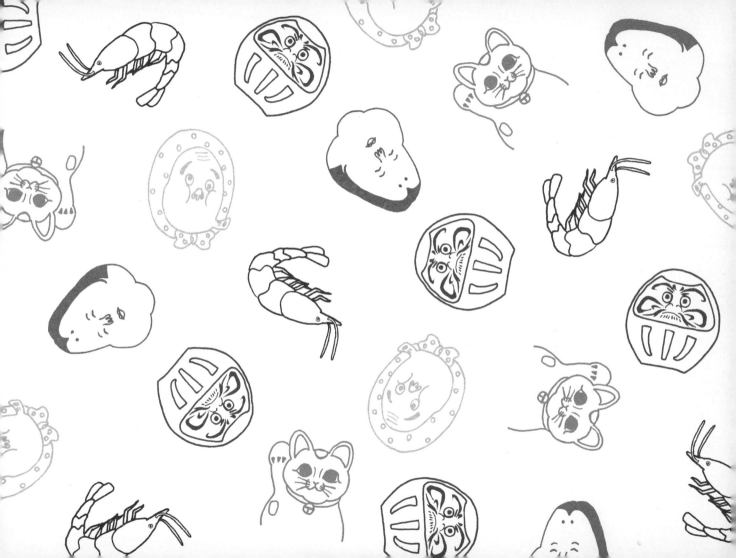

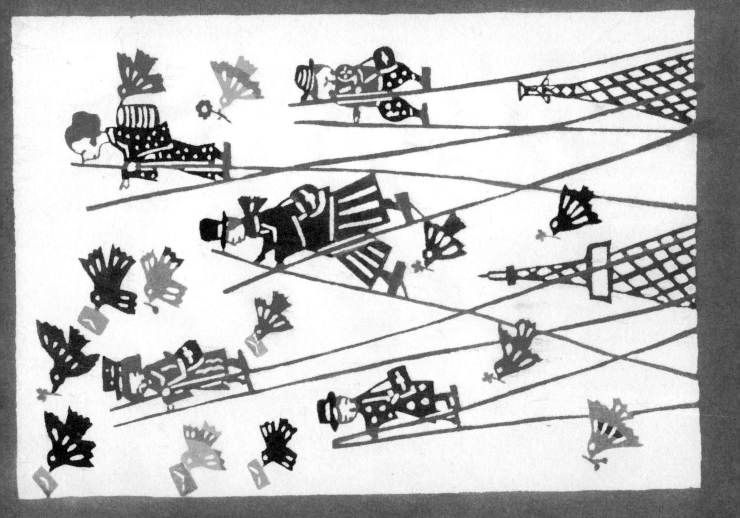

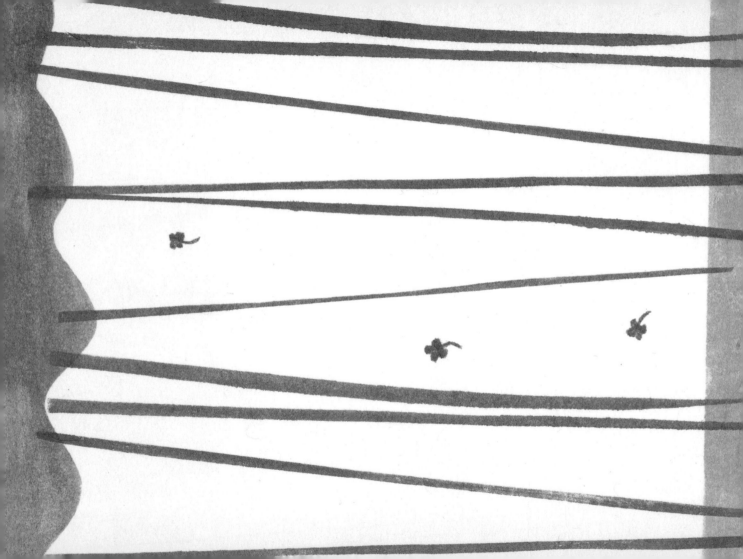

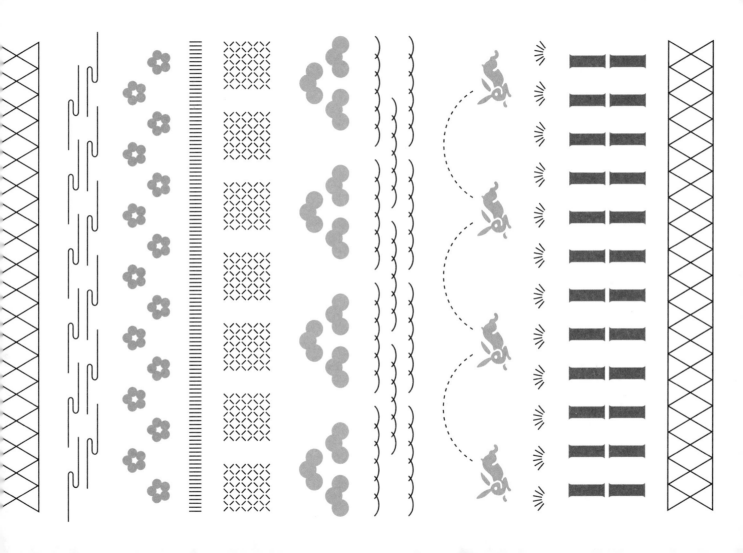

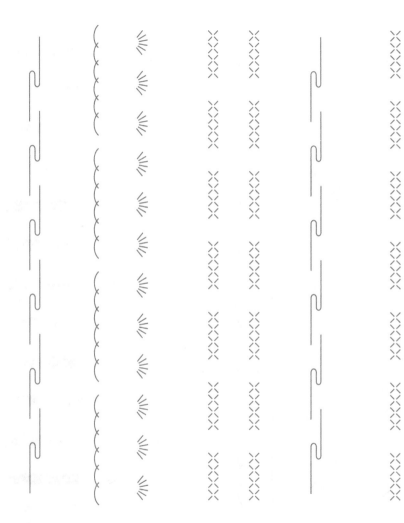

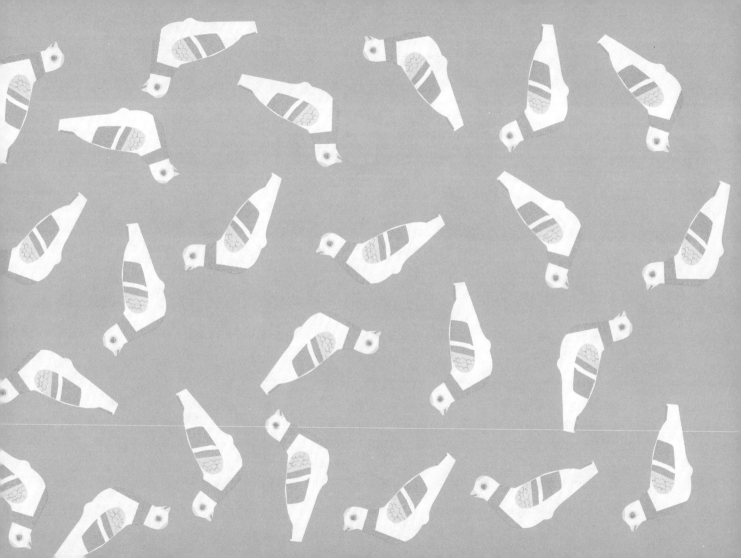

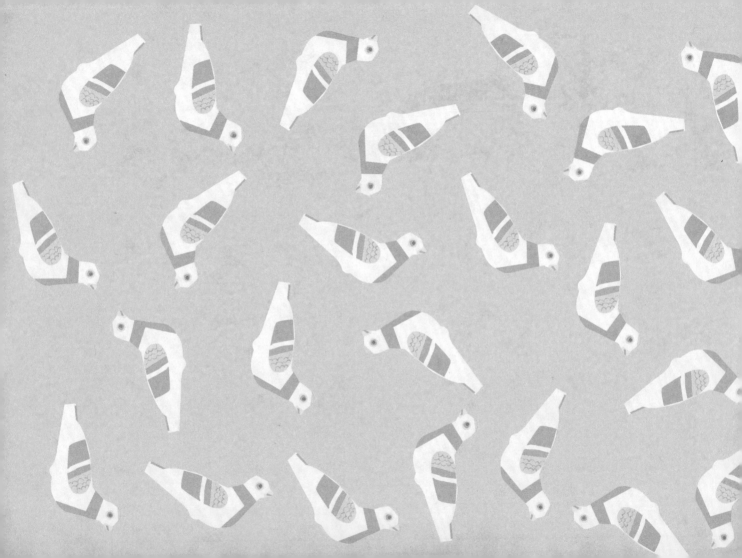